IMAGES
of America

GOLD RUSH TOWNS
OF NEVADA COUNTY

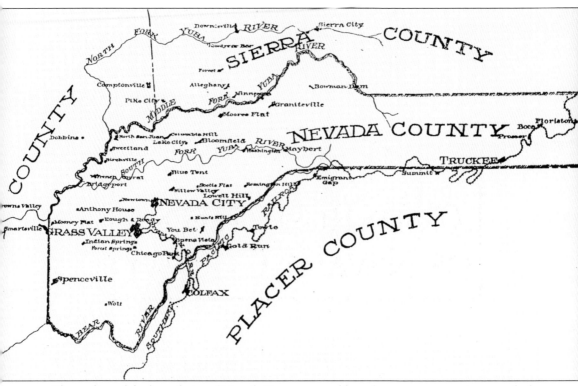

The outline of the boundaries of Nevada County resembles a firearm, perpetuating a myth that the shape purposefully signifies the Wild West and gunslingers. The boundaries were created by the California State Legislature in 1851, decades before aerial photography, and any resemblance to a firearm is a coincidence. Most of the county's boundary lines follow natural watercourses and are not man-made. (Courtesy author.)

ON THE COVER: This is the last crew of the Derbec Mine in North Bloomfield. From its discovery until it ceased operation, it produced more than $1.5 million. William Watt, owner of the Massachusetts Mine in Grass Valley and discoverer of the Derbec in 1877, was on a trip to the mine in 1878 when he was injured by a runaway buggy. He died from injuries sustained in the accident a short time later. (Courtesy Searls Library.)

IMAGES
of America

GOLD RUSH TOWNS
OF NEVADA COUNTY

Maria E. Brower

ARCADIA
PUBLISHING

Copyright © 2006 by Maria E. Brower
ISBN 0-7385-4692-5

Published by Arcadia Publishing
Charleston SC, Chicago IL, Portsmouth NH, San Francisco CA

Printed in the United States of America

Library of Congress Catalog Card Number: 2006931277

For all general information contact Arcadia Publishing at:
Telephone 843-853-2070
Fax 843-853-0044
E-mail sales@arcadiapublishing.com
For customer service and orders:
Toll-Free 1-888-313-2665

Visit us on the Internet at www.arcadiapublishing.com

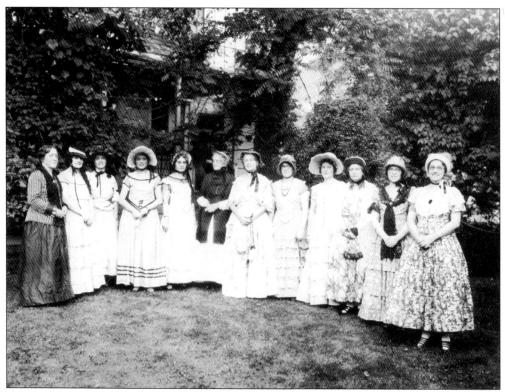

Wives and daughters of pioneers and miners wear gold rush–era costumes as they pose for this 1920 photograph. Pictured, from left to right, are Mary Stewart, Ann Morgan, Clara George, Ruth Rosener, Viola Shirkey, Mrs. Upton, Grace Archibald, Camille Bennett, Mae Curnow, Edna Sampson, Emily Granfell, and Mark Hartsuck. (Courtesy Searls Library.)

CONTENTS

ACKNOWLEDGMENTS

I wish to gratefully acknowledge the many wonderful people who have contributed in my effort to tell the story of the early gold rush camps and towns of Nevada County's past through this photographic history.

First my thanks of the Board of Directors of the Nevada County Historical Society (NCHS) for their cooperation, encouragement, and their faith in my ability to tell the exciting story of the early days of Nevada County. Special thanks to Priscilla van der Pas, president; Ed Tyson, director of the Searls Historical Library and his fine staff; Wally Hagaman, director of the Firehouse Museum; Glenn Jones, director of the North Star Mining Museum; and Madellyn Helling, director of the Railroad and Transportation Museum. My special thanks to NCHS members Pat Chesnut, David Comstock, Brita Rozynski, and Jack Clark for their support and their willingness to share their time and particular expertise with me. Friends are more precious than gold. To Steffanie Snyder and Su Black at the Doris Foley Library for treating me as a patron on my days off.

I give my deepest gratitude to the following people who submitted photographs, although I was not able to use all of them: Kathi Bristow, Brita Rozynski, Desmond Gallagher, Sue and Vern Gross, Bev and Bob Hailer, Sibley Hansen, Gage McKinney, Sandy Malos, Martha Miller, and Jennifer Taylor.

Last, but most important, I wish to thank my family—Jim, Tony, Cyndi, Jeff, Patty, Andrew, Rachael, and Jennifer—for their understanding of me being preoccupied for the last few months and busy most weekends researching, writing, and whittling down too much text.

I give a very special thank you to my husband, Jim, for his assistance with "anything to do with numbers" as the deadline approached and beyond.

INTRODUCTION

Nevada County embraces one of the richest mining regions in the world, and its mining districts rank among the highest gold-producing regions of California. Beginning with placer mining on the rivers, creeks, and streambeds after gold was discovered at Coloma, soon quartz mining was discovered. What had been dozens of rough-and-tumble mining camps soon became settled towns, some of which still exist today.

It all started with a fever, and there was no disease more contagious than "gold fever." Once contracted, there was only one cure—get to the gold fields as quickly as possible. Not doing so might mean it would be too late and all the gold would be long gone, taken by those who were fortunate enough to arrive in California the quickest, usually by the shortest route. If a person were in the states or across an ocean, there was no short or easy way to get there.

Misinformation and misconceptions about the California gold rush abounded, but the most important facts were true—there was gold, and it was free for the taking, or almost. Some effort had to be exerted to get it.

Those who were first to arrive found the gold easily, simply because there was such an abundance in the surface gravel of streambeds waiting to be found. Those were the forty-niners, the men—and a few women—who arrived in California in 1849 after President Polk gave credibility to reports of the gold discovery in his report to Congress. Early accounts in California newspapers of James Marshall's gold discovery at the site of John Sutter's water-powered sawmill on January 24, 1848, did not cause much of a reaction. But by the time the first ship arrived in San Francisco (then called Yerba Buena) carrying gold-seekers from the East, most of the extant population of California—5,000 men (and a smaller number of women and children)—was already working the rivers, streams, and creek beds searching and finding gold. Those living closer to California when they heard the news—in Oregon, the Sandwich Islands (Hawaiian Islands), Mexico, and South America—had a shorter journey, and their arrival in the summer of 1848 swelled the population. By the end of that year, thousands had already reached the diggings.

The forty-niners came from every walk of life, almost every county of the world, and every age group, but on the average, they were young. The younger men were able to pick up and leave home, not having the responsibility of a family, a farm, or a business to take care of or the difficulty of having to sell out first in order to raise money to go on "the adventure of a lifetime."

With gold fever so rampant, there were articles, pamphlets, and books printed that were quickly circulated with information on what supplies to bring to California. People believed it was easy to find gold and believed rumors that the streets were paved with gold or that one just bent down and picked it up from every river, stream, or creek bed. Some of the first to arrive in California and get up into the foothills were fortunate as there was so much gold wedged in crevices and rocks, dirt, gravel, or sandy-bottomed waterways that it did not take much effort. This hide-and-seek method required only perseverance and luck, not skill. But miners soon learned that they had to dig to find the gold, and with a little experience, they learned there were places that yielded

more treasure than others. After a few days on the water, gold seekers streamlined their method and learned the best places on the streams, rivers, and creeks to dig.

Using only crude and ordinary implements, some men got rich while most only earned wages equivalent to what they made back home. Prices for necessities, transportation, and goods were exorbitant. The only remedy was to find more gold or to keep from losing what had already been found. Wool blankets were used when the miners discovered they were losing a good amount of gold by panning or sluicing. Wet sand or dirt was spread on the top of blankets and left to dry, and then the blanket was shaken to reveal the heavier particles of gold stuck to the course wool.

Gold mining required a source of water, and miners immediately started diverting or damming creeks or digging channels to divert watercourses, sometimes over long distances through pipes or wooden flumes. The ingenious sold such water to other miners. Devices to wash dirt and rocks, like the long Tom and the sluice box, became as common as the pan and shovel in mining camps.

There were very few experienced miners among those who arrived in 1849, except perhaps the ones who came from Mexico. The Mexicans, and especially the Sonorans, brought wooden bowls used in placer mining to California, having worked in the mines in their country. It wasn't long before the gold seekers were using a rocker, or "cradle" as some would call them, as they were rocked like a baby's cradle to wash more dirt and do it more efficiently. By the early 1850s, newcomers found that the easy pickings along every river, stream, and creek bed had been worked, and the pay dirt gone.

The early camps had colorful names, honoring favorite people, places back home, physical characteristics of the land, or were simply whimsical. Rough and Ready, You Bet, Red Dog, Little York, French Corral, Eureka, Blue Tent, Humbug, and San Juan (later changed to North San Juan so as not to confuse it with another early California town of the same name) are a few that sprang up first as camps and later became booming mining towns in Nevada County. Each town has a story, and photographs are all that remain of the booming towns that once spread from one end of Nevada County to the other.

For the next two decades, quartz and hydraulic mining would make Nevada famous around the world. Miners from Cornwall came by the hundreds to use their experience in Cornwall's tin mines in the depths of Nevada County's deep quartz mines. Investors from San Francisco, New York, Britain, and Europe abounded, as small mines were bought out and consumed by corporations that could afford to purchase the expensive equipment and machinery needed to extract the quartz and tunnel deeper into the earth to find the rich veins of gold.

One

PANNING, ROCKING, SLUICING, AND QUARTZ

It was a common belief that the placer gold had washed down from one gigantic source called El Dorado, which gold seekers hoped to find. As each ship disembarked in San Francisco or a party arrived overland, gold seekers made their way up into the foothills and soon the waterways were crowded. Word spread quickly about each new strike. If miners worked too long in a location without finding "color," they usually moved on, following reports of rich strikes elsewhere. Sometimes others would take up the same spot and strike pay dirt.

In the early days of the gold rush, it was almost impossible not to find gold if one was in the right place at the right time—even using crude and basic tools such as knives, pans, picks, crowbars, and shovels. Although most new arrivals to the gold fields had never mined before, they brought their own skills and experience. As they garnered on-the-job training, they invented tools and devices that made their tedious labor of bending over a creek or stream with a dirt-filled pan easier. Once they mastered the swirl that retained (hopefully) the heavier gold particles, the work was faster. Time was money, as the placer gold was bound to run out.

Gold Hill marker at Grass Valley, Calif.
Eastman's Studio B-5644

Gold Hill marker was placed where George McKnight was said to have discovered gold in quartz rock in 1850, just north of where he was working a small creek channel. McKnight stubbed his toe on a rock outcrop and in anger kicked the rock. He noticed a glitter coming from the newly broken surface of the rock he had dislodged. (Courtesy Doris Foley Library.)

Some men purchased elaborate devices and contraptions to bring to the California gold fields. After the long trip to California, the equipment was abandoned when found to be useless. The standard tools for forty-niners were the pan, shovel, and pick. Miners coming from Mexico brought with them a wooden bowl, and some of the early American and European miners adopted it. (Courtesy Doris Foley Library.)

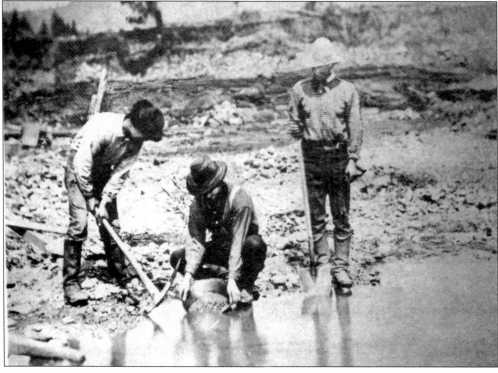

Not dressed in standard mining attire but using typical mining tools, these two couples, Mr. and Mrs. Andrew Goring and Mr. and Mrs. Charles Graham, are trying their luck on Deer Creek in Nevada City. They may have been visitors passing through the county. (Courtesy Doris Foley Library.)

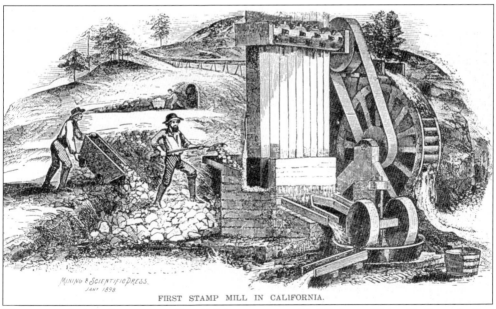

FIRST STAMP MILL IN CALIFORNIA.

This postcard of the first stamp mill in California appeared in *Mining and Scientific Press*, the San Francisco publication devoted to mining news in the West, in January 1898. The first mill, the Stockton, was built in Boston Ravine in 1851 by Halstead and Wright. The machinery imported from Mexico had two mortars, and the pestle was moved by steam; this operation crushed the rock in order for the gold to be extracted. (Courtesy Searls Library.)

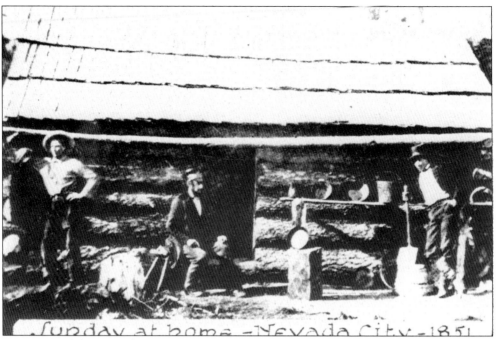

Sunday at home — Nevada City — 1851

A majority of the men who came from the "states" to the gold rush came with friends or family from back home. Others formed alliances on the journey to California, partnerships or groups named "companies" that often sold stock. The buy-in money was used to fund the venture and pay expenses once a claim was found. (Courtesy author.)

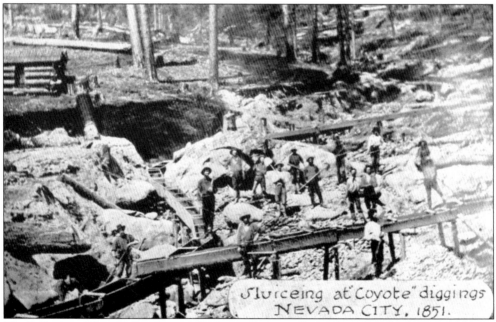

Sluiceing at "Coyote" diggings NEVADA CITY, 1851.

The hills above Nevada City became known as Coyoteville for the holes that miners dug every few feet searching for gold, which resembled coyote holes. The area proved to be very rich, and the new system of mining was so successful, that word spread quickly to other sections of the gold region both north and south of Nevada City. (Courtesy Brita Rozynski.)

12

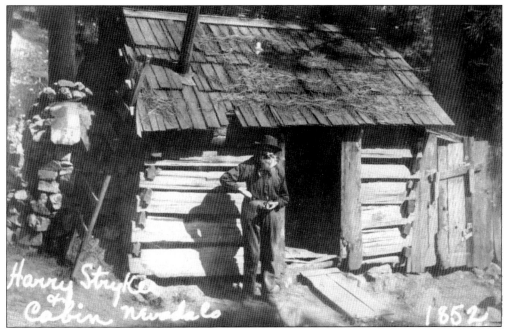

Most early miners were transient and moved often to follow each new rumor of a rich strike. Harry Stryke poses in front of his cabin in 1852. The materials used to build a cabin were abundant in most of the county; felling trees brought logs, shingles, and wood, and the rocks used for his fireplace or cook stove, pictured above, were plentiful. (Courtesy Searls Library.)

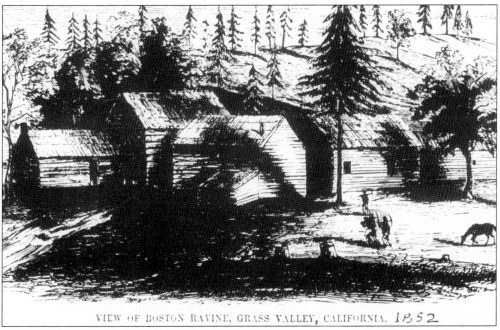

Boston Ravine was located a half mile below today's present town of Grass Valley in the area of Empire and Mill Streets. A company of men arrived September 23, 1849, and built four cabins where they spent the winter. Rev. H. Cummings, president of the group named the Boston Company, officiated at the first Christian burial in Nevada County. (Courtesy author.)

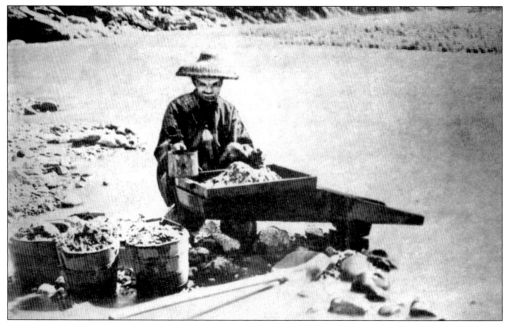

The Chinese miners became experts at "rocking the cradle," an early method of washing pay dirt. The dirt was shoveled or put in buckets before being dumped into the sieve or hopper of the cradle. Water was poured over it, and the cradle was rocked from side to side. This photograph shows a miner working alone, which was unusual, especially with the Chinese. (Courtesy Doris Foley Library.)

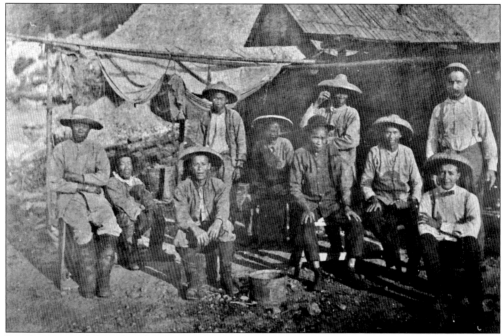

It is documented that the Chinese miners ate better and were healthier than any other nationality in the mining camps and towns. They grew their own vegetables and herbs, which they had imported from China. Photographs of early camps, such as this one of Red Dog, are very rare, as are photographs of Chinese miners. (Courtesy Searls Library.)

Gold was transported to the Nevada City office of Wells Fargo and Company from up-country mines. Nevada City and Grass Valley played an important part in the early history of the company in California, and offices were opened in both towns in 1853. Alonzo Delano was the first manager at Grass Valley, known throughout the mines under his pen name of "Old Block." (Courtesy Searls Library.)

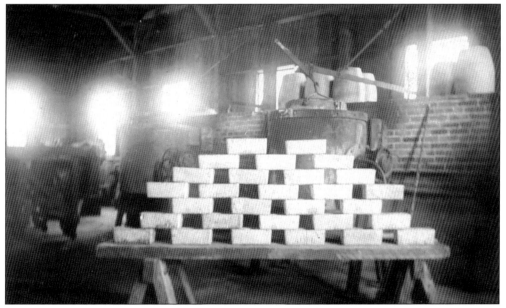

Gold melted and cast into bars becomes bullion. In 1883, $12,000 in gold bricks was piled on the counter of Citizen's Bank, ready for shipment to San Francisco. The day before, Wells Fargo and Company had shipped $10,000 out of the county. The gold bullion above is from the Idaho Maryland Mine in Grass Valley. (Courtesy Searls Library.)

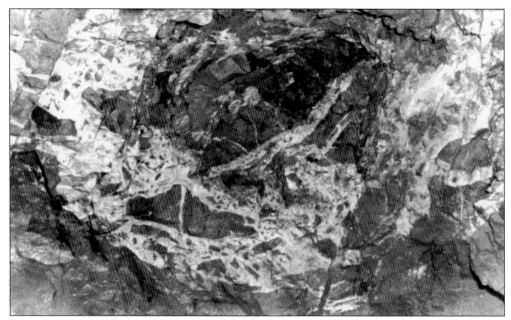

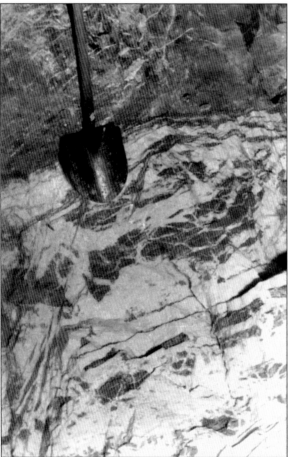

Underground at the Brunswick Mine in Grass Valley, a two- to three and a half foot vein runs through this quartz ledge. The ores of Grass Valley occur in veins caused by fissures in the rocks being filled with quartz and minerals, which were shot up from the depths of the earth perhaps millions of years ago. The Brunswick became part of the Idaho Maryland Mines Corporation. (Courtesy Searls Library.)

While flakes and nuggets were what was commonly found by the forty-niners during the gold rush; it was the deep quartz mines that Nevada City and Grass Valley are famous for. A standard-size shovel is used to show the width of the gold embedded in this quartz ledge at the Brunswick Mine. (Courtesy Searls Library.)

Two

THE BIG SPLASH

The adage "necessity is the mother of invention" never proved truer than in the California gold rush. Antoine Chabot, a French Canadian sailor working his claim seven miles outside Nevada City, looked for an easier way to move water for his ground-sluicing operation. He stitched heavy canvas and cut up saddlebags to fashion a 100-foot hose, six inches in diameter. His success encouraged other miners to make their own hoses.

While working his gravel claim at Nevada City's American Hill, miner Edward E. Matteson first came up with the idea of using water under pressure to wash great amounts of dirt in a short amount of time. A local tinsmith, Eli Miller, was hired to improve the idea by constructing a tapered nozzle out of sheet metal that attached to the canvas hose. As word of the innovation spread, hydraulic mining was born.

The largest and most famous hydraulic mining operation in California was Malakoff Diggings in the North Bloomfield Mining District, originally called Humbug. Hillsides and mountains were washed away by water traveling at a rate of 150 feet per second, and debris and silt ended up flowing down to the lower valleys and farmland. Hydraulic mining drastically declined after federal court judge Lorenzo Sawyer rendered his decision to make the practice illegal on January 9, 1884, after three years of court battles. Without mining to support workers and their families, many communities became ghost towns, taken back over by Mother Nature.

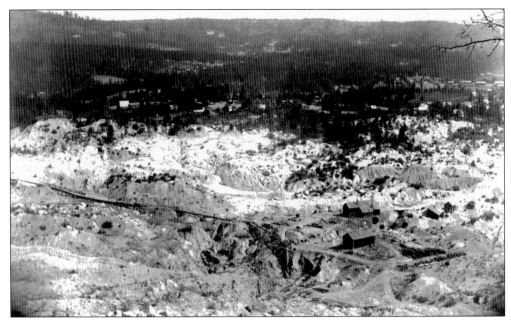

Edward Matteson developed hydraulic mining at American Hill while working the ground by sluicing at his claim outside Nevada City. He wondered what would happen if a stream of water was directed against the base of a hill after attaching a nozzle. In March 1853, he bought water from the Rock Creek Water Company and attached a metal funnel that tapered to the hose. (Courtesy Searls Library.)

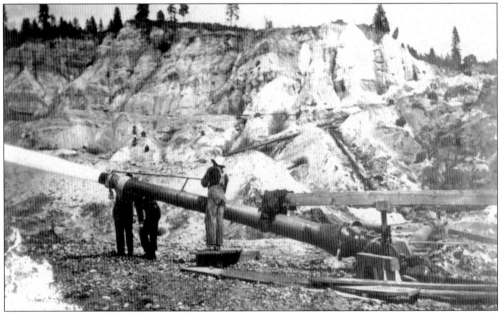

The first crude hoses and nozzles of the 1850s developed into powerful giant monitors. The hydraulic operations proved richly profitable to the owners, as the great force of water dislodged the deposits of deep gravel with fewer men working the claims. The profit from the gravel mines was immense, and it is documented that hydraulic mining produced 90 percent of California's gold for decades. (Courtesy Searls Library.)

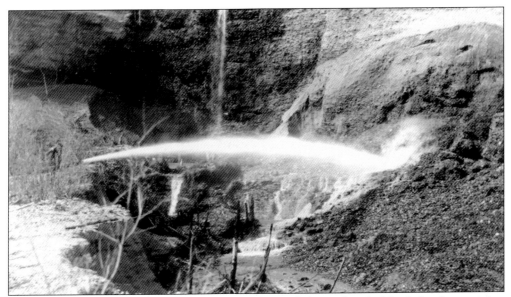

Extensive hydraulic mining was carried on at Badger Hill, located in the North San Juan mining district. By 1891, 20 million cubic yards of gravel had been excavated in that district. The Badger Hill claim was owned by the River Mines Company, and George W. Starr (Empire Mine fame) of Grass Valley was the manager. (Courtesy author.)

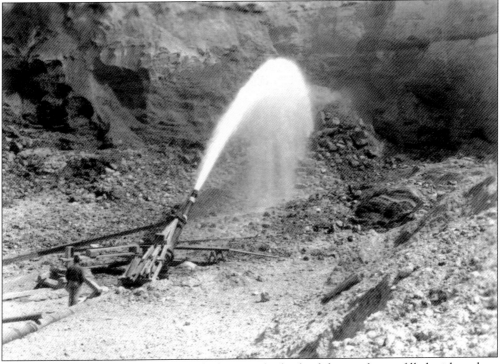

In the front left of this photograph, the box on the back of the nozzle was filled with rock to weigh down and counterbalance the force of the water and keep it in place. After the hillside was washed down, the miners would collect the rock in order to process it, which was often dangerous as the hills became unstable. (Courtesy Searls Library.)

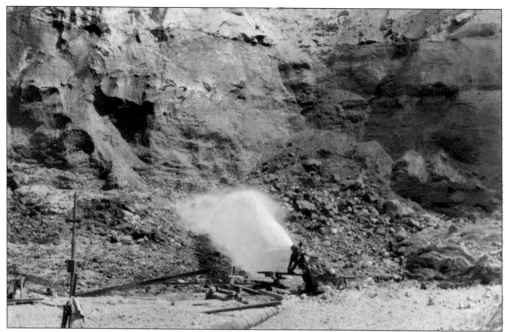

Relief Hill, located on the South Yuba River three miles east of North Bloomfield, was first settled in 1853 by prospectors. Like many small mining camps, it never became a town of any size, but by the mid-1850s, it had stores, saloons, and hotels. In 1947, the area was gaining a small comeback, once the scene of extensive mining operations more than 80 years before. (Courtesy Searls Library.)

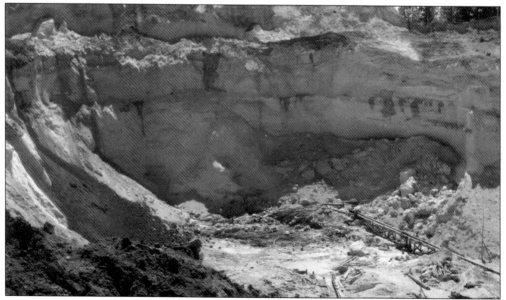

Buried in the gravel were the rich deposits of ancient rivers, and to reach them, the barren surface needed to be removed. In 1937, the Relief Hill Gravel Mine was the first to take advantage of the narrows tailings dam, first called Upper Narrows Dam, which is today's Englebright Lake. The photograph above shows the result of whole mountainsides that were washed away during the decades of hydraulic mining. (Courtesy Searls Library.)

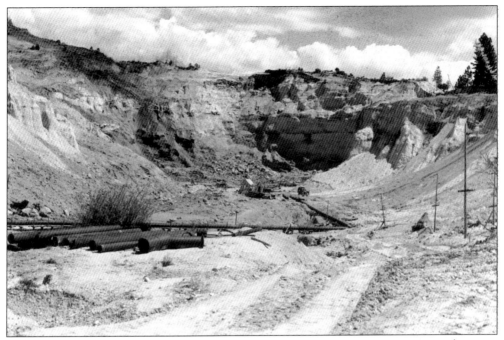

This 1947 photograph of Relief Hill shows the large pipes used to carry water over great distances that connect to the monitor. The roar from a 15-foot monitor could be heard a half mile away. A machine shop at each of the larger mines would be able to repair almost any leak or breakdown without going into Nevada City and causing a delay. (Courtesy Searls Library.)

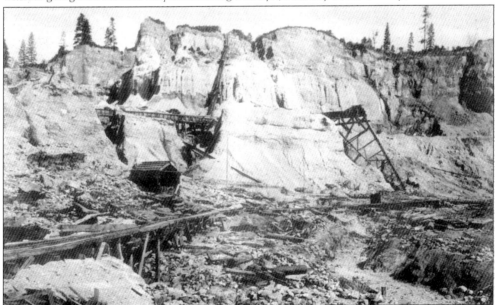

The North Bloomfield Gravel Mining Company consisted of 1,585 acres of the main gravel channel near the town of Bloomfield (later changed to North Bloomfield) in the central part of Nevada County, 14 miles northeast of Nevada City. The North Bloomfield mining district included the region around North Bloomfield, Columbia Hill, Malakoff, Relief, Lake City, Snow Tent, Moore's Flat, Orleans Flat, and Snow Point. (Courtesy Doris Foley Library.)

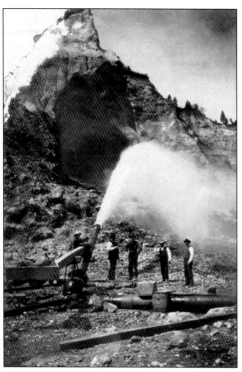

In 1880, hydraulic mining reached a peak in California. It was an 1884 California court ruling by Judge Lorenzo Sawyer that eventually put an end to most hydraulic mining. Sawyer issued an injunction saying all mining was to cease unless it could be done "so as to not injure valleys." This photograph shows the Malakoff in North Bloomfield. (Courtesy Searls Library.)

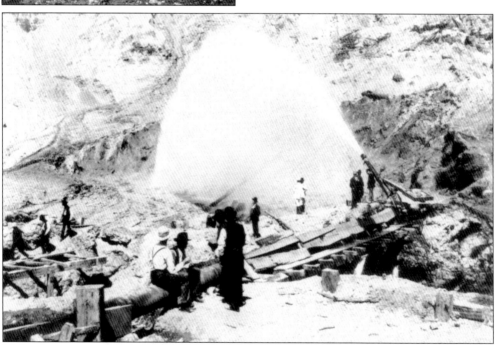

Hydraulic mines could operate after 1884 if the owners constructed tailings dams to prevent debris from being dumped into the Sacramento and San Joaquin Rivers and their tributaries. In 1893, the Caminetti Act was passed, creating the California Debris Commission. Licenses for hydraulic mines could be granted if mines were assessed to make sure any debris dams built were sufficient and in compliance. (Courtesy Searls Library.)

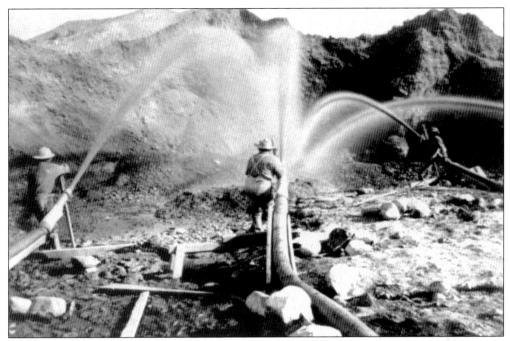

The town of French Corral was named for a mule enclosure erected by a Frenchman. The district included the region around French Corral, Bridgeport, Allison Ranch (not Grass Valley), Ray's Ranch, Montezuma Hill, and Purdon Bridge. In 1867, a telephone line was operating between French Corral and French Lake, 60 miles away, to send messages to the ditch tenders to regulate the flow of water to the mines. (Courtesy Searls Library.)

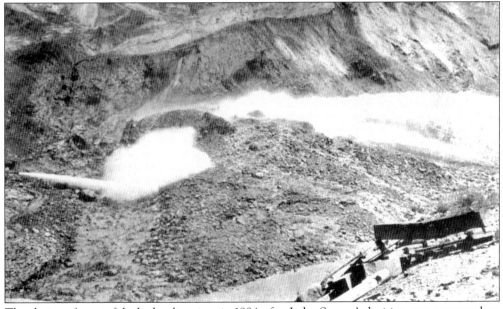

The closing of most of the hydraulic mines in 1884, after Judge Sawyer's decision, was a tremendous loss to the state and nation but more to Nevada County. From 1848 to 1965, Nevada County's gold production alone was $440 million, more than double Amador, the second-highest producing county. (Courtesy Searls Library.)

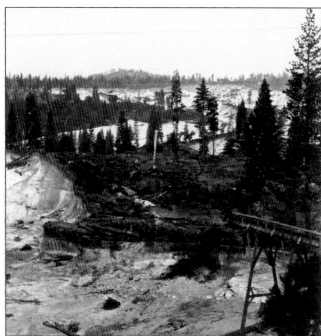

Columbia Hill is pictured here in 1866 from the Union Diggings near Lake City. A constant problem during hydraulic mining was the filling up of the open flumes with debris. Not having sufficient water to keep the flumes flowing and clear would slow down or stop the miners from working, and if work slowed down, men would move on to better diggings where water was available. (Courtesy Searls Library.)

Piles of old diggings are pictured on the south fork of the Yuba beyond the town of Washington. After the white miners moved on, the Chinese would work the tailings left behind and make a living from the gold they found. The tailings that were left behind after the Chinese finished working them can still be seen today. (Courtesy Searls Library.)

24

Three

FOUNDRIES, MACHINERY, AND EQUIPMENT

The success of mining in Nevada County was in large part supported by the foundries in Grass Valley and Nevada City, which also supported local businesses, industries, and later the Nevada County narrow-gauge railroad. In 1848, California was on the far reaches of the United States and half a world away from Europe and the British Isles. Not only was it costly to transport necessities and luxuries to California, it was an additional expense to haul them up to the foothills and high country of the northern mines. As mining progressed, local foundries opened and expanded to keep up with the unique needs and growth of a booming industry. Local foundries worked with mine owners or engineers to develop the specialized parts and machinery to tool the growing industry.

There is disagreement as to when the gold rush ended—some say as early as the mid-1850s. But even at the height of mining, many miners realized that there was an easier way to make a living, especially when the return was not even enough to survive in an inflated economy. The men who stayed used their talents and former trades, opening businesses as blacksmiths, millers, and carpenters to meet the ever-increasing needs of mining and other related industries.

The discovery of gold in quartz and hard-rock mining, the kind of mining that made Grass Valley and Nevada City famous, had the greatest impact on industry. Individual mines were sold to corporations because tunneling deep into the earth required expensive machinery and technology, as well as large amounts of capital. Some investors were willing to gamble that a potential vein would pay, and pay big, after expenses and months of labor.

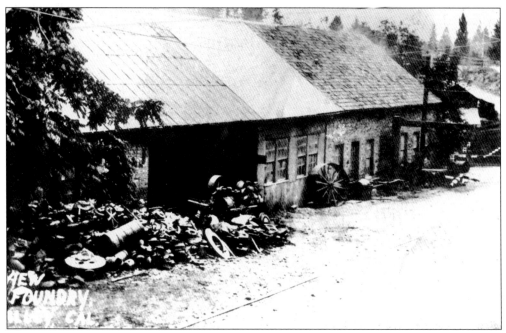

Taylor's Foundry was located in Boston Ravine between Mill Street and Wolf Creek. Irish immigrant Michael C. Taylor's first building, completed in 1861, was built of native stone, baked brick, and hand-hewn timbers but was destroyed by fire, along with his second structure. Many "firsts" were created at the foundry, including the first cast-iron water pipes and fire hydrant fittings for Grass Valley. (Courtesy Jennifer Taylor.)

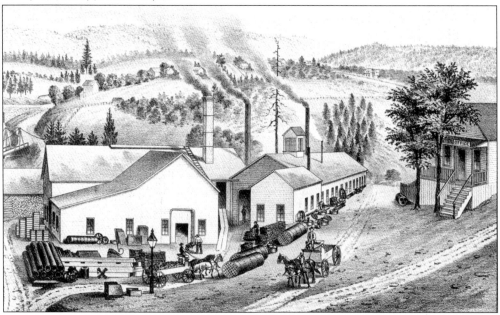

This drawing was produced for the *1880 History of Nevada County* published by Thompson and West. The Nevada Foundry in Nevada City was built by Edward Coker in 1855 on Spring Street behind the National Hotel, but it burned in the 1856. Coker rebuilt at the present foundry's location. After several ownership changes, George Allen became the sole owner in 1876. (Courtesy author.)

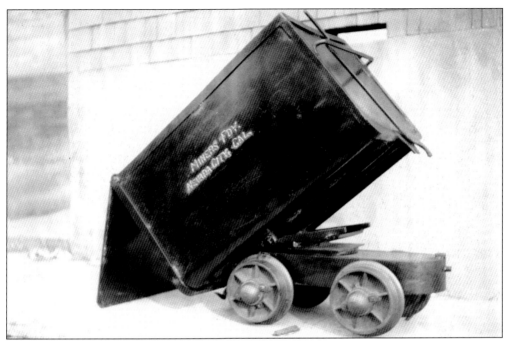

The left end opens to dump the ore in this end-dumping ore car that was manufactured at the Miners Foundry. The Miners Foundry has operated under the names Nevada Foundry and Allen's Foundry. By 1859, it opened as the Miners Foundry under the new owners. (Courtesy Sibley Hansen.)

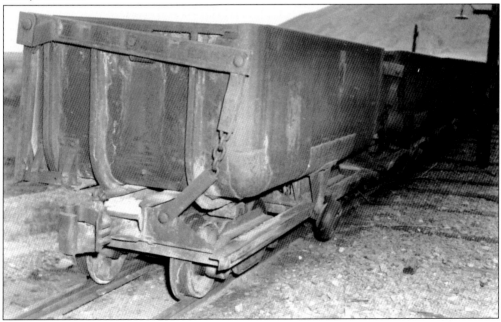

On the left side of this photograph is the side-dump ore car manufactured at the Miners Foundry. Able to compete with San Francisco prices, the foundry made mining equipment and tools for most of the mines in Nevada County. In 1872, the North Bloomfield Mining Company purchased $30,000 in equipment in one month. (Courtesy Sibley Hansen.)

Ore skip was used in a vertical shaft for hoisting ore at a Grass Valley mine. In the early days, if the mines failed, it was most often due to mine owners or operators who had poor machinery and little capital. Mines that had mills on-site and a means to perfect their machinery by experiment seldom failed. (Courtesy Sibley Hansen.)

Ore skip, pictured here on the tracks at an unidentified mine in the Grass Valley mining district, was manufactured for use on an incline shaft. The smaller-diameter flanges welded to the wheels were used automatically to dump ore in the head-frame bins. (Courtesy Sibley Hansen.)

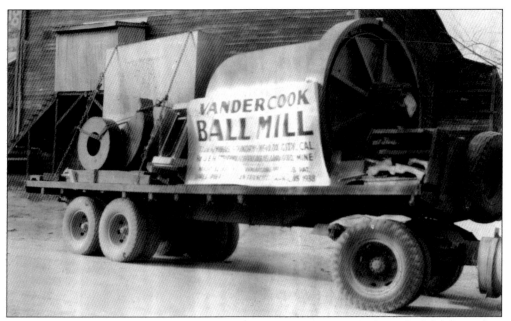

A ball mill was a revolving steel drum partly filled with steel balls, which crushed the ore as they rolled over it. The sign reads, "Vandercook Ball Mill and feed scoop manufactured at Miners Foundry in Nevada City." This 1938 photograph shows the back of Armory Hall, which was demolished in 1940 to build a modern store on Broad Street. (Courtesy Sibley Hansen.)

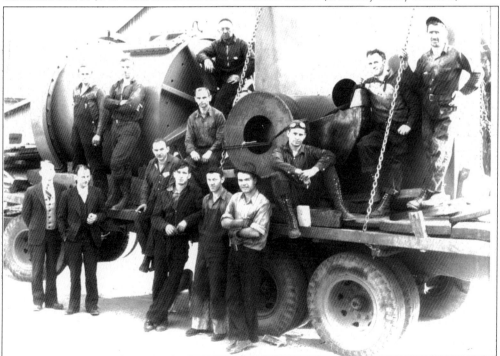

This is a large ball mill loaded on a truck at the Miners Foundry in Nevada City. Roy Zimmerman sits on the truck at right, and Charlie Hosking is sitting near the top at the rear of the ball mill. Other men in the photograph are unidentified. (Courtesy Sibley Hansen.)

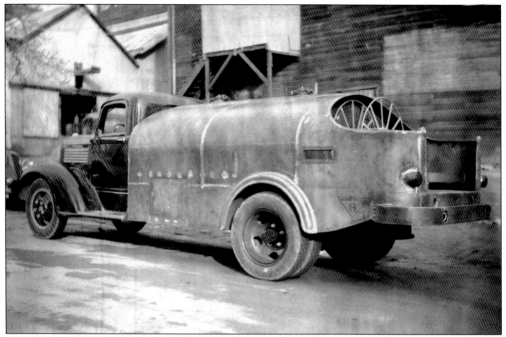

The Miners Foundry manufactured not only machinery and equipment for the mining industry but other businesses as well, such as this gasoline or oil truck. In the background is the old Armory building, which was torn down to build a modern grocery store, the Purity Store, currently housing the Bonanza Market. (Courtesy Sibley Hansen.)

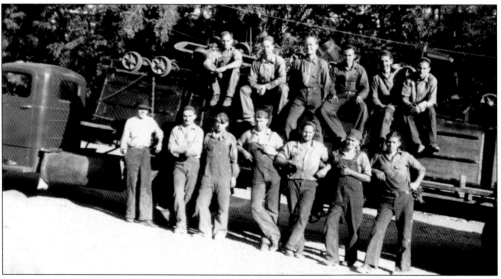

Equipment and ore cars are being delivered from Miners Foundry. Pictured sometime before 1940 is Roman Rozynski (top row, second from left), before he left for South America to work in a gold mine. Men who had worked in Grass Valley would be hired at mines around the world for their expertise and experience in quartz mining. (Courtesy Sibley Hansen.)

This is believed to be one of the machine shops at the Miners Foundry. In 1947, the foundry and manufacturing company added two new departments. They became sales agents for Lincoln Welding Supplies, Bethlehem Wire Rope, Esco Legging Supplies, and Gates Rubber Products, and they started production on the RYP Healthmaster centrifugal juicer. (Courtesy Doris Foley Library.)

There were many other jobs and processes at a quartz mine and mill above ground. Pictured here at an unidentified mine mill are flotation cells used in a mill circuit to separate metallic minerals (concentrates) from the pulverized ore. (Courtesy Sibley Hansen.)

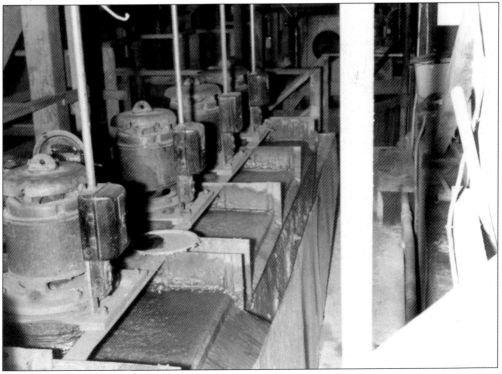

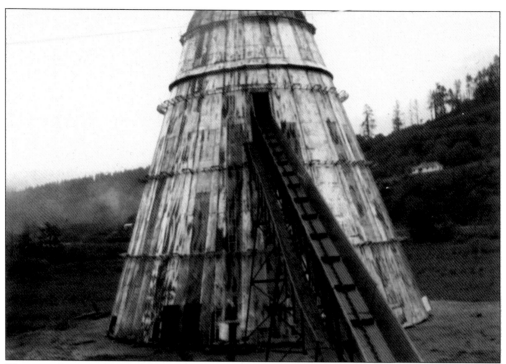

This is a photograph of a sawdust burner at a local mill in Grass Valley; the door at the bottom shows the scale of the burner. Lumber was a major industry in Nevada County. The lush growth of trees and surrounding forests supported the vast amount of lumber that the mines used to shore up underground tunnels. (Courtesy Sibley Hansen.)

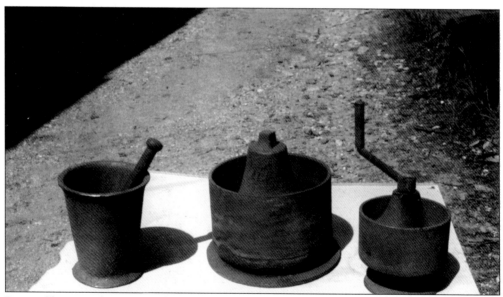

Pictured here are three types of pestles for grinding rock, probably used in early assay to test ore for the value of metal it contained. Nevada City and Grass Valley quartz mines were not only known as big producers but also for their rich grade of ore. (Courtesy Sibley Hansen.)

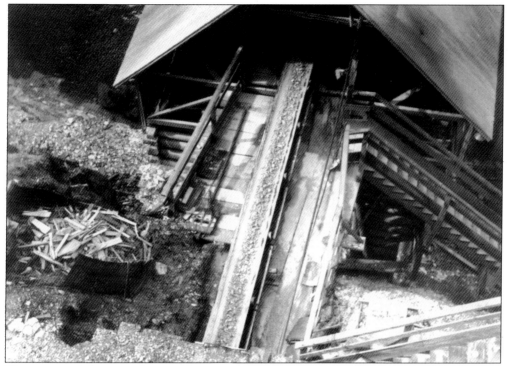

The conveyer belt pictured was used to move ore at a mining and mill operation. After the larger quartz mines closed down their underground operations and during World War II, they continued to mill ore and do cleanup work. After the war, many mines could not reopen due to the cost to dewater the long-neglected mines. (Courtesy Sibley Hansen.)

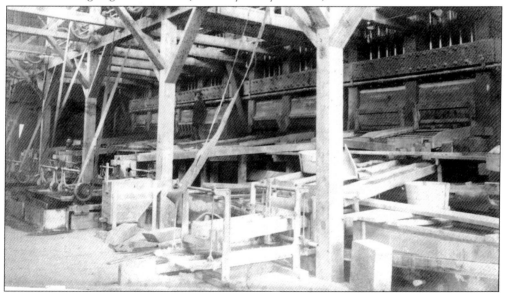

Pictured here is the interior of a mine stamp mill. The larger mines had their own mills and shops that produced equipment and made repairs. A broken piece of equipment could shut down the mine; it was costly for both the mine owners and investors and cost the workers a loss of salary. This trickled down to the merchants and other local businesses. (Courtesy Searls Library.)

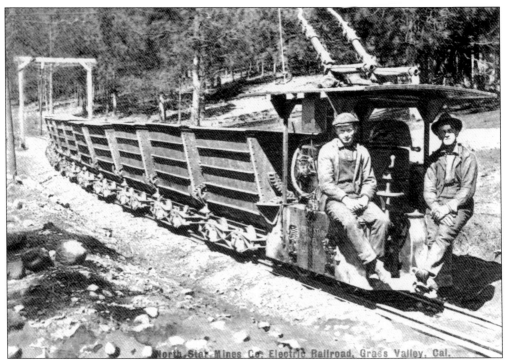

The North Star Mine's two-foot gauge, Baldwin-Westinghouse locomotive in Grass Valley connected the central shaft and the old North Star Shaft with the mill and the dumps. (Courtesy Searls Library.)

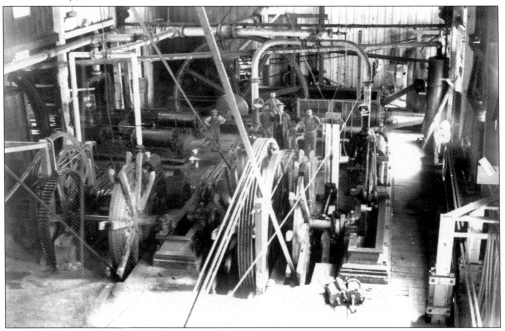

This 1870s photograph of the ground interior of the hoisting works shows winding reels and flat steel dabbles that were used for lifting at the Idaho Maryland Mine in Grass Valley. (Courtesy Searls Library.)

At an unidentified mine and mill, cyanide vats sit outside. Cyanide is a compound of carbon and nitrogen. In mining, either potassium or sodium cyanide was used in the milling process to extract the gold from waste material. Chemicals used in mining were commonly dumped in the ground and can be a cause of contamination to the soil and groundwater today. (Courtesy Sibley Hansen.)

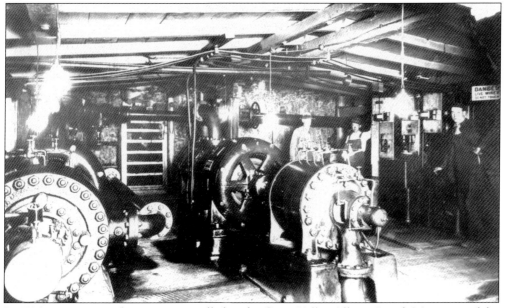

In 1896, pumping machinery was installed at the Grass Valley Allison Ranch Mine, one of the leading mines in the district at one time. The pump had a capacity of 1,080,000 gallons per 24 hours. This would drain the mine so development could commence after 28 years of neglect by the previous owners. Steam was used as the power. (Courtesy Searls Library.)

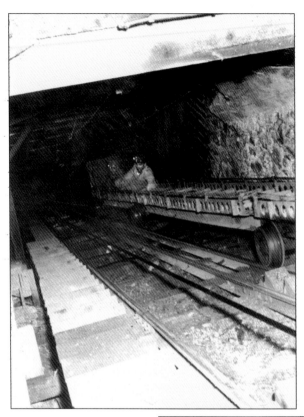

The North Star vein, discovered in 1851 west of Wolf Creek in Grass Valley, was also known as the Lafayette, a lead discovered by a French company on the edge of Lafayette Hill about one and a half miles south of Grass Valley. Underground track and skip could move miners and supplies through the compartments and shafts. The utility compartment carried compressed air pipes, water lines, and electric cables. (Courtesy Searls Library.)

The world-famous, California-built Pelton wheel pictured here was invented in 1879 by Lester Pelton, a mill man and carpenter living in Camptonville. The large steel wheel has odd-shaped buckets attached to the outer rim. In mining districts where water was abundant, Pelton wheels were cheaper than steam engines and more efficient. The first Pelton wheels were manufactured at Allen's Foundry in Nevada City. (Courtesy Searls Library.)

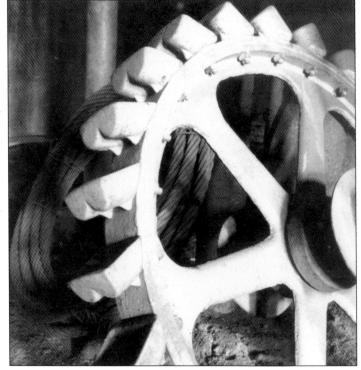

Four

GETTING FROM
HERE TO THERE

A majority of the gold rush miners were transients. Finding gold was their primary focus, and they moved on if they did not find "pay dirt." There was always news of a big strike at some other camp, river, or stream.

Early roads were no more than unimproved trails blazed by Native Americans and animals, inadequate for wagons and the traffic the gold rush brought. In heavy rain and snow, the wagons and animals would become mired, accidents would occur, and eventually the roads became impassable. Improvement of the roads and bridges to the mining camps began with private toll roads that charged travelers a fee.

Once arriving in the foothills and on their way to the higher county, miners would encounter both their greatest obstacle and necessity—water. Water was the most important natural resource besides the gold itself, and both its scarcity and overabundance would be a curse to the miners. Miners waited for the spring thaw in order to resume mining and the fast-moving currents loosened gold deposits along creeks and rivers. They could not work on snowy banks or in frozen streams, or even icy water for very long. They also needed a nearby source of water for drinking, cooking, and sanitation.

The same waterways that were so important to the miner's survival were also their biggest hindrance in getting to the mining camps and towns. New bridges spanning rivers and creeks cut travel to the various camps and towns that had often great been great distances apart by miles.

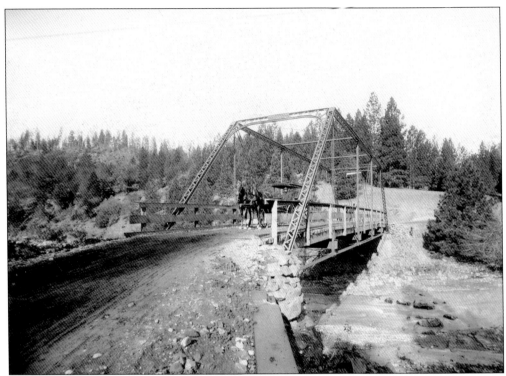

Pictured is the early bridge on McCourtney Road to Grass Valley. Charging the wagons and foot and cattle traffic a toll to cross, the owner recouped the expense of building and maintaining the bridge and the road on each side of it. If the road was not maintained and the bridge kept in good order, then the owner could lose his license to operate it. (Courtesy Searls Library.)

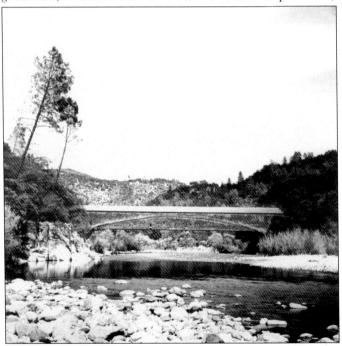

The Bridgeport Bridge that spans the South Yuba River was built by David I. Wood using Howe trusses, upon which an auxiliary arch was framed and to which counter struts were added. This composite structure was somewhat similar to the design first used by Theodore Burr for a bridge constructed in 1804 across the Hudson River. (Courtesy Searls Library.)

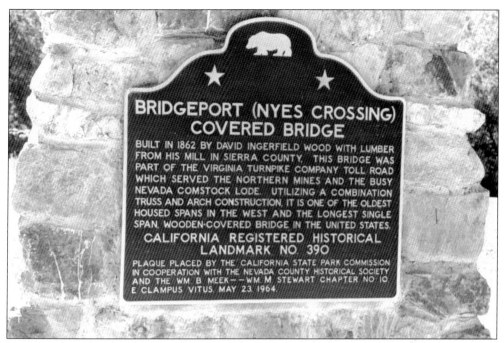

Designated as a historical landmark in 1948, the bridge was built in 1862 by Wood, who was part of a company of men from Virginia originally named the Virginia Turnpike Company. Nevada County can boast it as being the largest single-span wooden covered bridge in the United States. It is now part of the California State Parks system. (Courtesy Searls Library.)

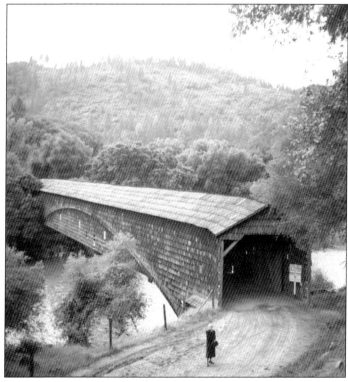

This is a view of the old Bridgeport Bridge before reconstruction work was completed. In 1969, a committee was formed to raise funding for the project, and the restoration was completed in 1971. In 1984, funds from voter-approved state bonds made money available for the California State Parks to purchase the bridge and surrounding area for a state park and to develop a wilderness trail. (Courtesy Searls Library.)

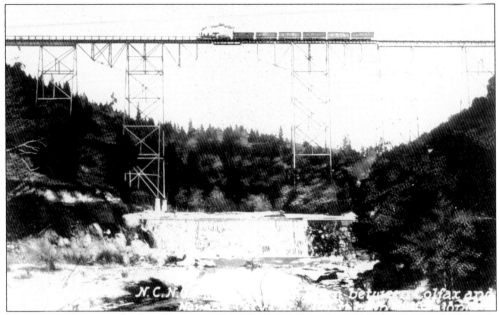

The new bridge over the Bear River was completed in November 1908. As soon as the Nevada County Narrow Gage Railroad (NCNGRR) opened, gold shipments could travel safely by train from Grass Valley and Nevada City to the new mint in San Francisco. A small iron safe was installed in the baggage compartment of each combination coach of the NCNGRR. (Courtesy Brita Rozynski.)

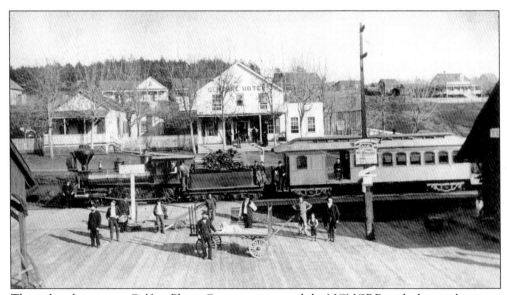

The railroad station at Colfax, Placer County, connected the NCNGRR with the regular-gauge Central Pacific (CP). Officers of the NCNGRR being mine owners was no coincidence; the largest backers of a proposed railroad linking the Nevada County mining towns to the CP would eventually benefit them. For 27 years, stage robbers plagued gold shipments between the mines and San Francisco. (Courtesy Searls Library.)

Town Talk Tunnel, built on the divide between Grass Valley and Nevada City and completed on December 20, 1875, was named for the Town Talk Mine. The area was settled in the early 1850s and 1860s and proved rich in what Nevada County is most famous for—gold. (Courtesy Searls Library.)

At Chicago Park, a wood stack is ready to be loaded on the NCNGRR engine near Wolford's mill. There was a train station at Chicago Park, between Colfax and Grass Valley, and special picnic and excursion trains ran in the summer carrying thousands of people to Storm's Ranch for annual celebrations. Picnicking, swimming games, and music were the order of the day. (Courtesy Searls Library.)

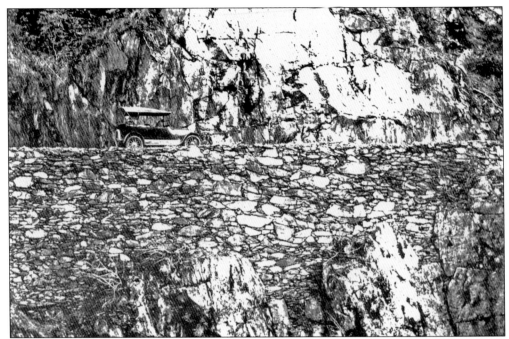

The name Tyler Foote Crossing is a misnomer. The road was originally called Foote's Crossing, built by civil and mining engineer Arthur De Wint Foote in 1913 as an easier route between his mining interests at the North Star Mine in Grass Valley and the rich Tightner Mine near Alleghany. Tyler was once the name of the town of Cherokee. (Courtesy Searls Library.)

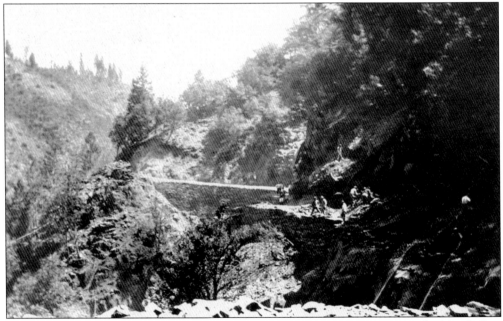

This 1912 view shows the construction of Foote road. Foote was manager at the North Star and approached the Nevada County Board of Supervisors to submit his proposal and contract guaranteeing the construction of the 22-mile road from the Delhi Mine to the middle of the Yuba River, as well as a bridge across the river for a stated sum. (Courtesy Searls Library.)

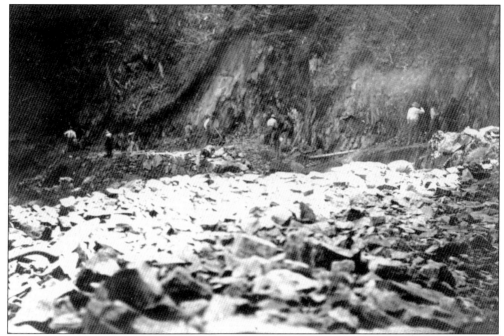

On the Nevada County side, Foote road went from Nevada City to Columbia Hill via Edwards Crossing, and then to a point above the Delhi Mine and the middle Yuba River. The road on the Sierra County side of the highway skirted Kanaka Creek to Alleghany. It was 13 miles shorter than the old road in use at the time. (Courtesy Searls Library.)

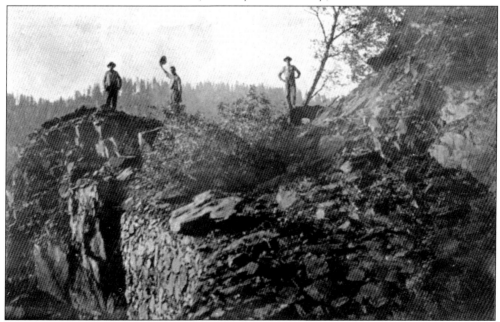

This was what much of the terrain looked like when construction of the Foote road commenced—an amazing feat considering it was done without machinery, only teams of animals and manpower. In places, the wagons wound around bluffs 500 feet above the canyon below. After completion, the road could be traveled practically all seasons of the year. (Courtesy Searls Library.)

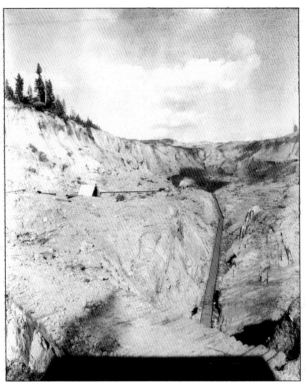

A spray of water can be seen in the middle of this photograph showing hundreds of feet of flume carrying water to a crib dam in the foreground. Hydraulic mining was not possible without a vast water supply to the diggings. Mines often shut down from April to June if water was not available and in heavy winters could not resume until the snow melted. (Courtesy Searls Library.)

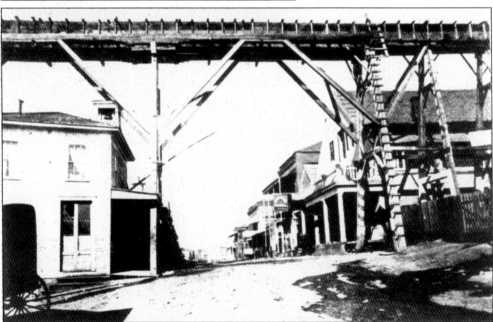

This early photograph shows a flume running through the middle of the town of North San Juan, born as a result of the surrounding hydraulic mines. The flume brought water from the Yuba River into town and neighboring diggings. It was 1,200 feet long and 48 feet high. Flume Street derived its name from this flume. The *Hydraulic Press* was the name of the town's newspaper. (Courtesy Searls Library.)

Gold rush technology advanced America's race for riches. Updated sluicing methods and devices were built and evolved quickly. This photograph shows sluicing at the shaft house of a mine as a monitor is sending water to the sluice box. The sluice, like the long tom and rocker, employed gravity to move the heavier gold from the lighter sand and gravel. (Courtesy Searls Library.)

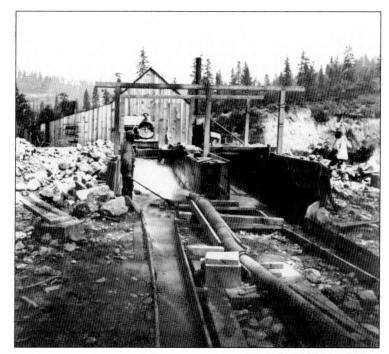

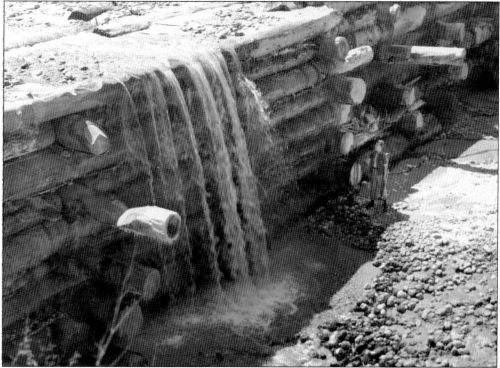

A slit or "crib" dam was made out of logs. Holes were blasted in the side of a hill, and every eight feet a pole was placed, starting with the first row of logs and adding more until the desired height was reached. It was then filled with gravel, and the water poured over the top of the dam. This is the silt dam at Scotchman Creek in 1942. (Courtesy Searls Library.)

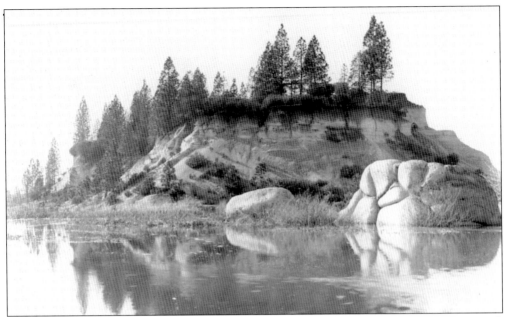

The Hirshman hydraulic diggings outside of Nevada City included a water reservoir, or pond, which many used for swimming in the warmer months. Eventually most of the hill pictured in the center of photograph would be blasted away except for a very small section that had a pine tree clinging to its roots. The Lone Pine was a longtime Nevada City landmark. (Courtesy Searls Library.)

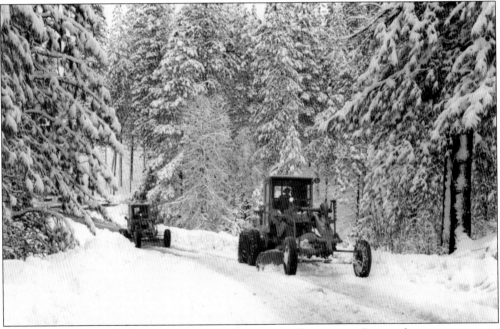

Early sleighs were pulled by horses to reach the surrounding towns. Later, when autos were in use, most of the up-country towns still used horse-drawn wagons for transportation since roads were not yet paved and the going was rough. Here two "modern" snow tractors remove snow from county roads in Nevada County. (Courtesy author.)

Five

GRASS VALLEY

Since the discovery of gold-bearing quartz in 1850, Grass Valley has been the leading gold producer in California. As miners flocked to small settlements in the foothills like Boston Ravine and Gold Hill, Grass Valley emerged as the leading economy in the state for over a century with fortunes that shifted with the price and output of gold. It was said that any man who had a resume with mining experience in this district could get a job at any mine anywhere in the world.

The Cornish dominated jobs and mines in Grass Valley. Bringing with them hundreds of years of experience working underground in the ancient tin and copper mines of Cornwall, they were the world's greatest hard-rock miners. Arriving with the quartz boom of the 1860s, Cornish men were experts at sinking shafts and had a "nose for ore," inventing the famous Cornish pump used to remove water from the mines.

Even after the federal government passed the infamous War Production Board Limitation Order L-208 on October 8, 1942, which crippled the gold-mining industry in the nation, Grass Valley did not dwindle to a ghost town as other mining communities did. After the order was lifted on July 1, 1945, production resumed, but in the interim, the shafts had flooded and the wooden beam supports had rotted. The water in the mines would have to be pumped out and extensive retrofitting and shoring up the hundreds of miles of tunnels would have to be done before mining could resume. Lower revenue and higher production costs, not the lack of gold buried deep under Grass Valley, finally closed down the last two mines—Empire-Star Limited and Idaho Maryland Mines, Inc.—in 1956.

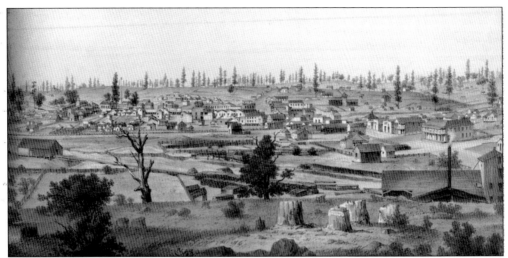

This 1858 lithograph of Grass Valley shows the stark difference from the early days when the area was surrounded by forests. Trees were cut down in every direction around the town, as was the case in nearly every gold rush town and camp in Nevada County. The trees were used for early shelter, fuel, erecting more permanent homes and businesses, and for shoring up the mines. (Courtesy author.)

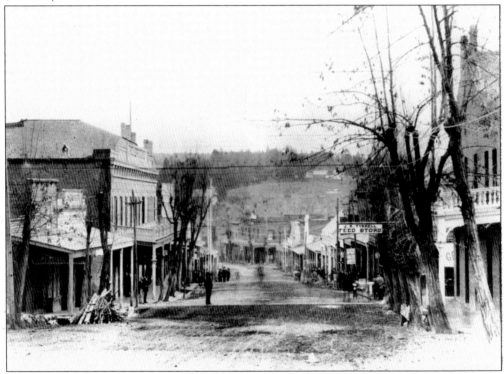

John Roland Tyrrell sold his feed store on Main Street to W. J. Mewten in December 1894. In 1895, he was elected justice of the peace of Grass Valley. By 1898, he was a lawyer, and between 1901 and 1904, he was a California senator serving the counties of Nevada, Placer, Plumas, and Sierra. His brother James Charles Tyrell became the editor of the *Tidings-Telegraph* and postmaster. (Courtesy Doris Foley Library.)

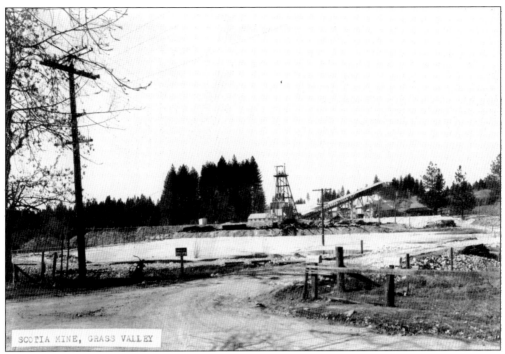

The Scotia Mine, pictured here around 1940, was located one-quarter mile west of Grass Valley. Like many of the smaller independent mines, it eventually was purchased by one of the big three mining companies—the Empire, North Star, or Idaho Maryland. The Scotia became part of the Empire-Star group, a result of the Empire Mine owner purchasing the North Star Mines Company. (Courtesy Searls Library.)

The shaft house and mill of the Union Hill Mine, one of the first veins to be discovered in the Grass Valley district, is pictured here around 1918. A mill and hoist were erected, and the mine operated until 1870, when it closed for 30 years. By 1918, it had become a part of the Idaho Maryland group, then Empire-Star. (Courtesy Searls Library.)

49

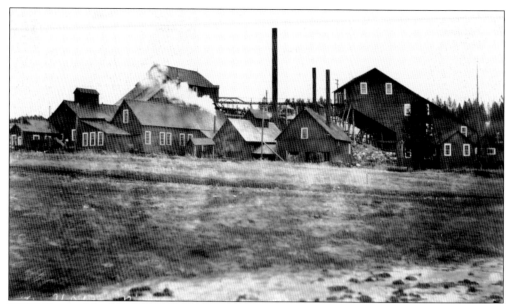

W.Y.O.D. stood for "Work Your Own Diggins." It was a venture of six young men, organized by Charles Brockington, his two brothers A. J. and Ed, W. J. Connors, and Pat and John Feeney in 1886. When the group formed, they had no capital but were determined to open their own mine. In the 1890s, the mine was known as the "best little mine in Grass Valley." (Courtesy author.)

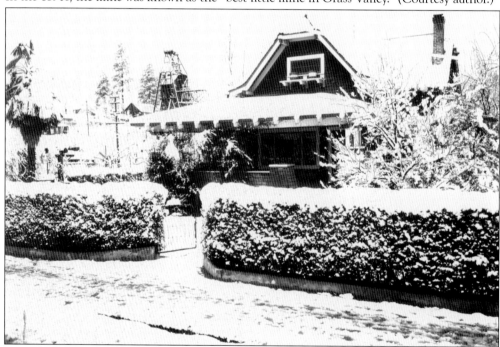

By 1891, the W.Y.O.D. was operating successfully. Brockington held controlling interest and sold the mine to Joe and Jake Weissbien, becoming partners with Susan Mills (founder of Mills College) in the Orleans Mine. He later owned the Sultana and eventually opened the profitable Golden Center Mine. The Golden Center Mine property was located where the Safeway store now stands in downtown Grass Valley. (Courtesy Searls Library.)

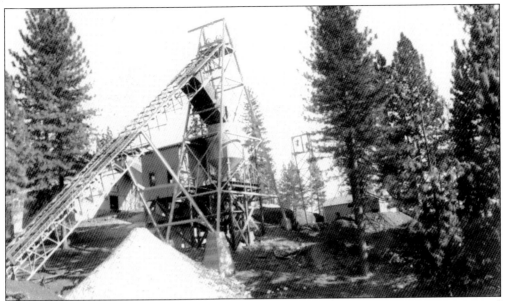

The Spring Hill Mine, showing the head frame and above ground buildings, was incorporated in 1870. The original ledge was only 800 feet, and the new owner, Ben Nathan, purchased 800 additional feet to the east and west. The Spring Hill Mine ran through serpentine about 500 feet deeper than the Alpha vein nearby and north of the Maryland and south of the Idaho veins. (Courtesy Searls Library.)

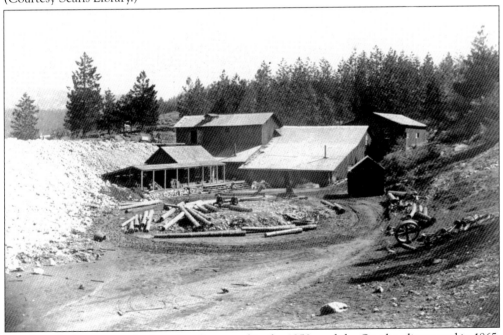

The Lone Jack was an early day mine discovered in the 1850s and the Omaha, discovered in 1865, became an extension to this mine. These claims merged in 1885 as the Omaha Consolidated. By 1903, the Omaha, Lone Jack, Wisconsin, Illinois, and Homeward Bound Mines were consolidated into the Empire West Mines Company and all came under the management of George Starr in Grass Valley. (Courtesy Searls Library.)

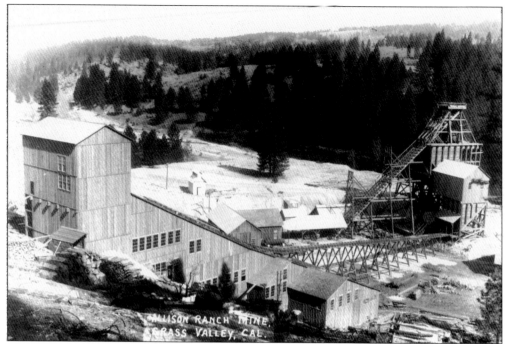

The Allison Ranch Mine, two and half miles south of Grass Valley, was discovered in the early 1850s. Its vein was discovered in 1854, and until 1866, it was one of the most famous producers in the Grass Valley mining district. During the Civil War, there was a great deal of political controversy connected with the mine. The group of miners belonged to the Copperhead political party, and the union supporters felt they should be driven from the neighborhood and the mine taken over by the government. (Courtesy Sue and Vern Gross.)

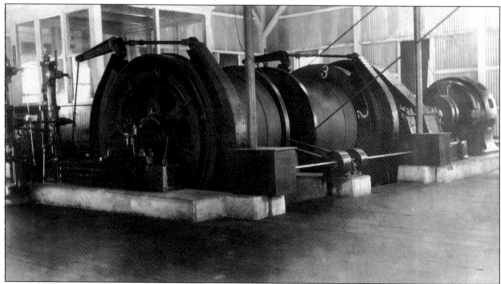

In 1887, the Allison Ranch Mine property went on the London market for $1,250,000, with 250,000 shares at $5 each; 167,000 were offered at public subscription. The large machinery above was used to drive the pumps as the shaft incline sunk to 1,650 feet near Wolf Creek, and 1,000 gallons of water per minute was pumped out. (Courtesy Searls Library.)

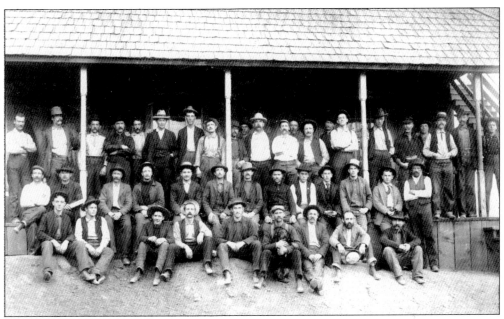

The Altoona Mining Company and boardinghouse in the Alta, Randolph, and Bunker Hill area is pictured here around 1898. The Hope Gravel Mining Company was organized in San Francisco in 1865 and started work on Alta Hill. In 1869, the company found a rich channel, which led other companies to work these hills, including the Altoona Mining Company, which brought a revival of placer mining to Grass Valley. (Courtesy Searls Library.)

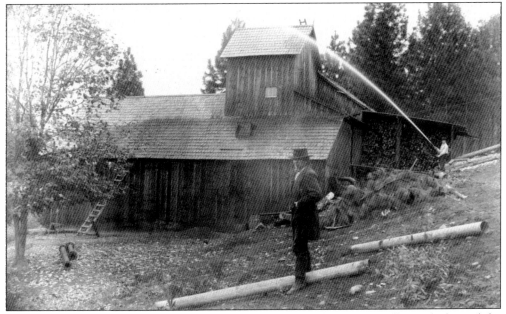

The old Maryland Mine was located one and a half miles east of Grass Valley and adjoined the famous Idaho on its eastern boundary. It was an extension of the same ledge, and after years of litigation and disputes between the owners of the mines because of the ore going through both properties, the Idaho was purchased by the Maryland Mine, and the company worked through the Idaho shaft thereafter. (Courtesy Searls Library.)

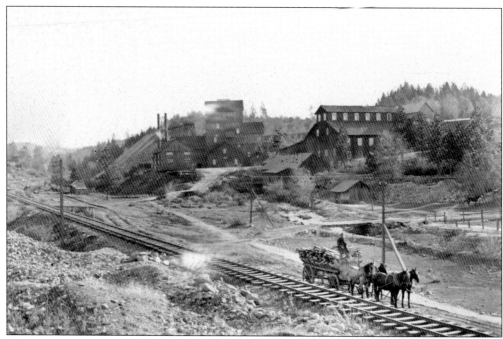

This 1893 or 1894 photograph was taken by Victor L. Dorsey, son of Samuel P. Dorsey, locator of the Maryland Mine in 1865. The NCNGRR track was completed in 1876 and the wagon pictured may have been picking up wood to operate the steam boilers. The train would have stopped at the Grass Valley depot to pick wood and load freight and passengers. (Courtesy Searls Library.)

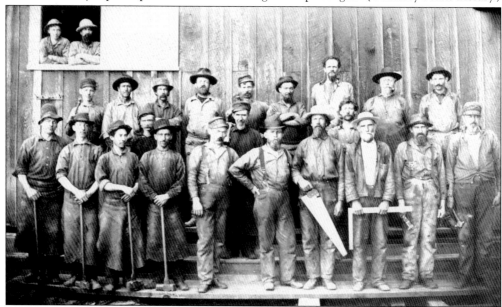

Surface crews at the Idaho Mine included skilled workers such as mill men, carpenters, and blacksmiths. The Idaho was the leading quartz mine in California from 1869 to 1892 and yielded $11,470,573 during that period. Many Grass Valley pioneers were associated with this mine, including the Coleman brothers Edward and John, William Watt, Jules Fricot, Alfred Dibble, and Alex Brady. (Courtesy Searls Library.)

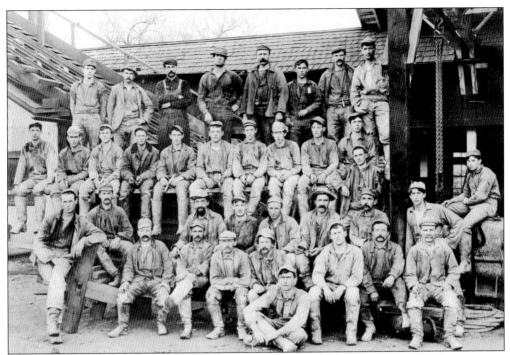

Pictured here is the crew of the Idaho Maryland in 1905. In 1901, the mine closed, but by the following year, the Idaho Maryland Development Company was formed. In 1904, surface repairs had been completed and pumps were put into operation to dewater the mine. As the water receded, it was evident that the shaft timber had to be replaced due to rotting or being crushed from the swelling. (Courtesy Searls Library.)

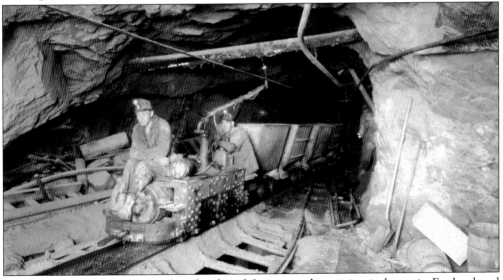

Tracks with moving cars were first developed for use in the mining industry in England and Europe to move heavy loads of rock and coal. That technology was later applied here and further developed for hauling freight and passengers. The above photograph shows the electric "trolley" locomotive and a string of ore cars at the 2,000-foot level at the Idaho Maryland Mine. (Courtesy Searls Library.)

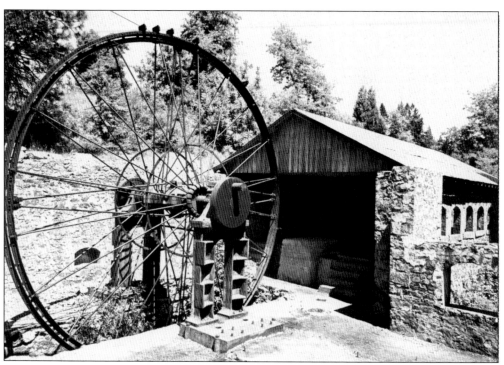

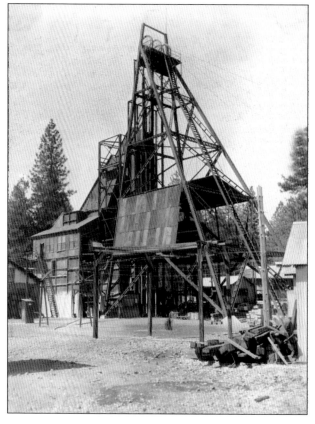

There were once three Pelton Wheels in the North Star Powerhouse. This 30-foot-diameter Pelton Wheel was, at the time, the world's largest, and it was installed in 1898. It was built to compress air for operation in the North Star Mine, the deepest of the Grass Valley mines with a vertical shaft of 4,000 feet. (Courtesy Searls Library.)

The Lafayette or French Lead vein was discovered in 1851. In 1860, Edward and John Coleman arrived in Grass Valley, purchased the largest interest in the Lafayette, and changed the name to North Star. In 1887, William Bourn, who had purchased it from the Coleman brothers in 1884, sold the mine to James D. Hague and Associates of New York. The North Star would be a big producer and opened to a depth of 8,500 feet on incline. (Courtesy Searls Library.)

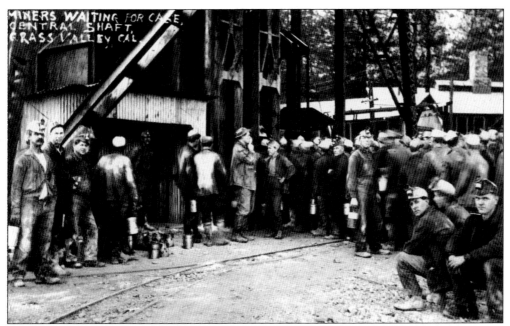

On May 2, 1919, the North Star was sold to the Newmont Mining Corporation, which had also acquired the Empire group. Its holdings contained several thousand acres of land, as well as mineral rights. This undated photograph shows the miners waiting for the "case" to take them below. (Courtesy Searls Library.)

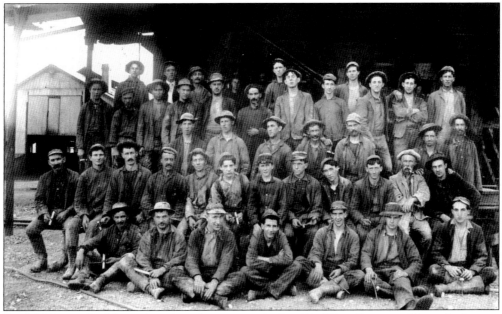

In 1895, James D. Hague hired civil engineer Arthur De Wint Foote and brought him to Grass Valley to design and construct an electric-generating plant to supply water to the mill. Foote studied the electrical installation and decided it was too unsafe and undependable for underground use at the time. Foote came up with a plan to use water-powered air compressors. (Courtesy Searls Library.)

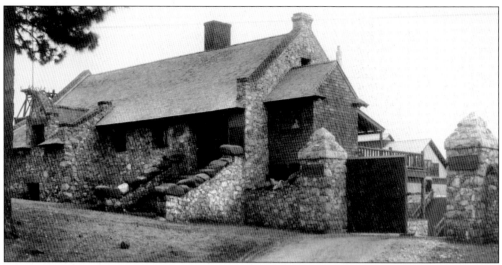

One of the earliest mines in Grass Valley, the Empire was the largest hard-rock mine in all of California. At its closure in 1956, the 105-year-old Empire held the record of being the oldest continuously worked gold mine in the United States. Pictured here is the former office, built from waste mine rock, as was the manor house and walls fronting the road through the grounds. (Courtesy Searls Library.)

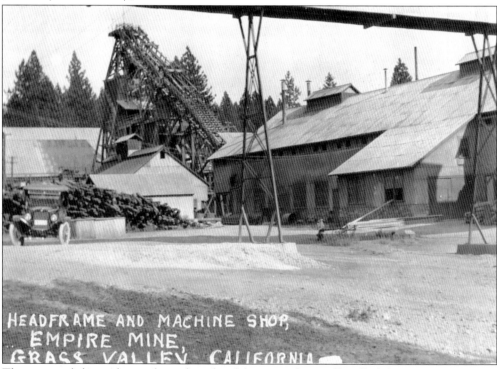

HEADFRAME AND MACHINE SHOP,
EMPIRE MINE,
GRASS VALLEY, CALIFORNIA

This postcard shows the machine shop, head frame, and catwalk called the "Rogues Gallery." The gallery went to the mill building and enabled the staff to use the mill unobserved. It was said to be a deterrent to prevent miners from high-grading—a common practice in the mines. The miners who stole the high-grade ore were crafty in smuggling the gold out of the mines. (Courtesy Searls Library.)

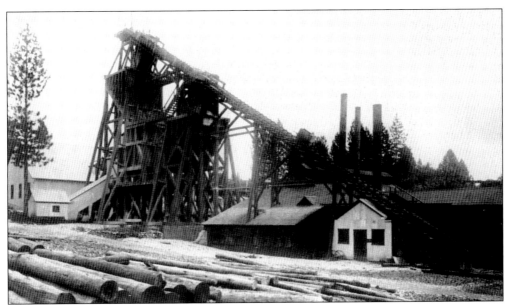

The ore cars made countless trips up and down the main Empire head frame. Determined to be a hazard due to crumbling, this head frame was blasted down on March 6, 1969. The Empire Mine State Historic Park is open daily in season and tours of the grounds, mansion, buildings, and part of a mine shaft are conducted. (Courtesy Searls Library.)

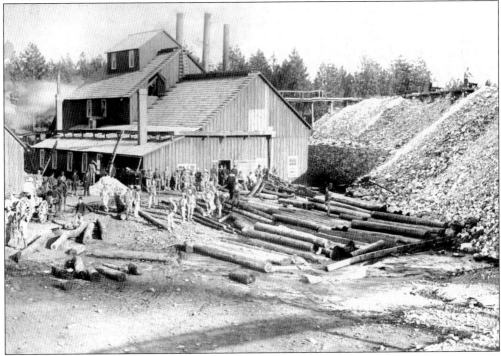

To the right of the building are mountains of mine tailings in this 1891 photograph. Thousands of trees were cut down and milled to support the hundreds of miles of underground tunnels the quartz mines of the Grass Valley Mining District needed. After mining, logging and agriculture were the other two largest industries in Nevada County. (Courtesy Searls Library.)

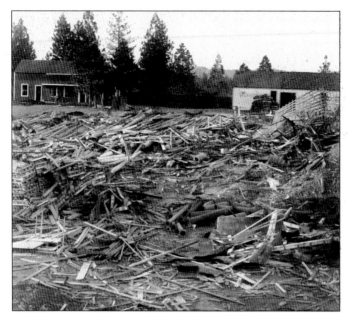

An explosion at the Empire Mine on March 14, 1888, resulted in two deaths, seriously injured several miners, and reduced the dry house to splinters. The steam whistle blew and immediately a loud explosion was heard throughout Grass Valley. Every building in town shook, and the town's people ran into the streets to see a great could of smoke rising from Ophir Hill. (Courtesy Searls Library.)

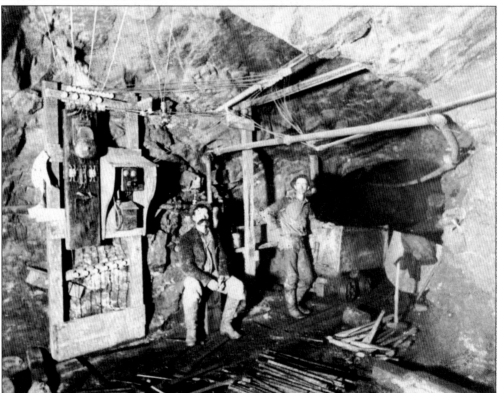

At the Empire Mine, 2,100 feet underground, the station shows a telephone, signal bells, and old wiring methods. In 1893, a bill was proposed by Sen. E. Voorhies, representing Alpine, Amador, Calaveras, and Mono Counties, to require mines to install and use a standard system of bell signals. The local miners were opposed to its passing, but it eventually became law. (Courtesy Searls Library.)

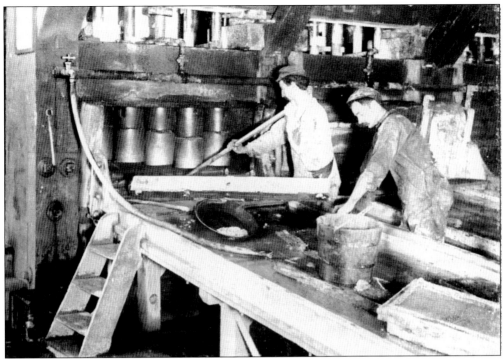

Amalgam is seen in the pan on the table being chiseled from the mortar. Gold would not break down small enough to go through the screen and would be trapped with mercury in the mortar. The amalgam that had become packed and wedged around the dig at the bottom of the mortar would have to be chiseled to become free. (Courtesy Searls Library.)

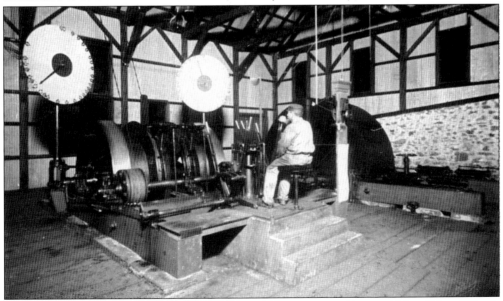

The Empire Mine hoisting works, pictured here c. 1900, was powered by two 10-foot Pelton Wheels (one in each direction). The drums were six feet in diameter with eight-foot friction bands, driven by two friction wheels made of compressed paper. Capacity of the hoist was 750 tons in 24 hours from a depth of 5,000 feet at a speed of 1,000 feet per minute. (Courtesy Searls Library.)

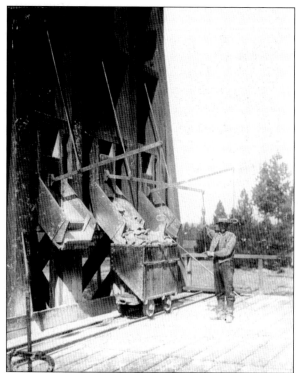

Waste bins at the Empire are dumping ore into ore cars c. 1900. By 1898, the gold in California was derived from only 12 counties: Nevada, Placer, Calaveras, Amador, Siskiyou, Trinity, El Dorado, Shasta, Sierra, San Diego, Kern, and Butte, with Nevada County producing one fifth of all the gold in the state. (Courtesy Searls Library.)

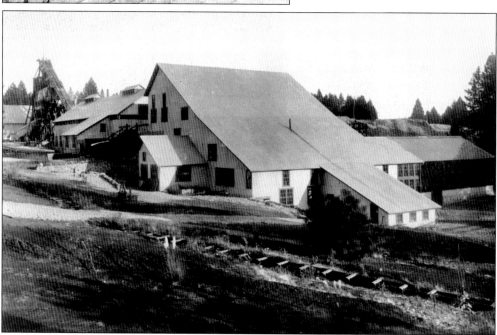

In 1942, when most mines were closed due to Order L-208, the Empire Mine was prosperous and employed 2,500 men with an annual payroll of $4,500,000. This photograph shows a general view of the surface plant and buildings. Today the mine grounds and surrounding property are some of the loveliest in Grass Valley and are a popular tourist attraction and event center. (Courtesy Searls Library.)

These miners are descending the main incline shaft of the Empire Mine sometime in the 1950s before the mine closed in 1956. At closure it employed 400 men and was California's last major gold-mining operation. The next two years were spent in cleanup and salvage operations. In 1975, the property was sold to the State of California. (Courtesy Searls Library.)

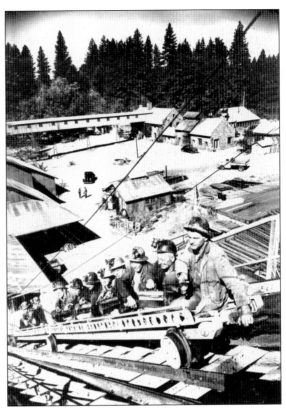

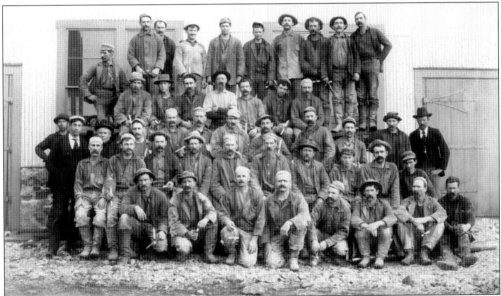

An Empire Mine crew poses for this photograph around 1900. Mining was hard work, and the miners labored long hours bringing up the rich ore for their employers. The 1890s brought great improvements and innovations in mining, milling, machinery, explosives, pumps, and electric power, all of which lowered mining costs and brought higher profits for the mine owners. In 1896, cyanide was introduced and replaced the chlorination process. (Courtesy Searls Library.)

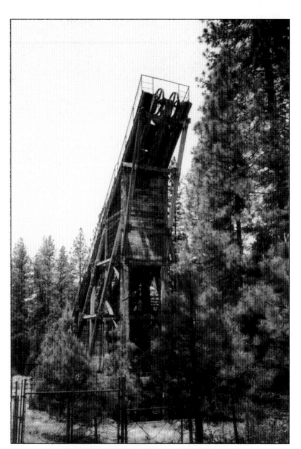

The Rowe Shaft and head frame stand a short distance from the main road leading into the park grounds from Highway 174. Named for William C. "Lamar" Rowe, the Rowe Shaft is the last mine head frame in the area. This shaft was opened in 1947 to speed up operations and provide an escape hatch if the main shaft became blocked. (Courtesy Bev and Bob Hailer.)

William Lamar Rowe was born in 1872 in Grass Valley, the son of immigrants from Cornwall. Rowe was the underground superintendent at the Empire Mine for many years. Upon his death in 1944, he was proclaimed "Grass Valley's most widely known citizen in the mining industry and fair and upright dealing while he served as underground mining superintendent." (Courtesy Bev and Bob Hailer.)

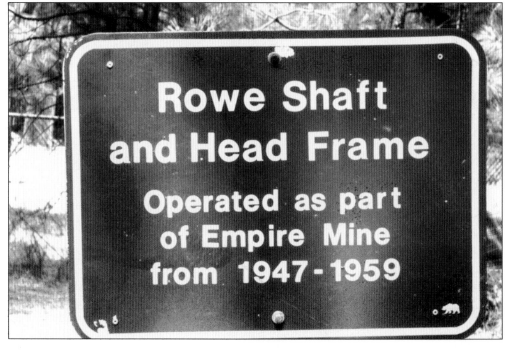

Six

NEVADA CITY AND WASHINGTON

In October 1849, Dr. A. B. Caldwell built a store of logs and the area became known as Caldwell's Upper Store to distinguish it from his other store four miles downstream. That same month, C. F. Stamps brought his wife (the first white woman) and children to the area. Mrs. Stamps died in June 1850. During 1850, the population increased to several hundred people, and stores, hotels, and cabins multiplied. A better name was sought for the town, and after writing names on slips of paper at a town meeting, the name Nevada was selected as the best and adopted.

As the community grew, men started working up the hillsides, which lead to the discovery of a rich vein that became known as Coyote Ravine. The Coyote Diggings derived its name from the holes the miners dug every few feet, resembling coyote holes. The holes were dug straight down in order to find a paying ledge or gravel channel. At first, the miners hauled the dirt in "cars" or buckets to be washed in Deer Creek, located at the foot of town. By 1851, the Rock Creek Ditch diverted water to the diggings, nine miles from Rock Creek. A few men had previously tried their luck on Deer Creek before the gold rush, and James W. Marshall, who discovered gold at Coloma, claimed that he led a party of immigrants through the area and camped overnight on Deer Creek. They did not find enough "color" and the party continued on their journey to the valley.

Nevada City was widely acclaimed as the prettiest of all the mountain towns in the northern mines, and by 1856, it was the largest and most prosperous town in Nevada County.

The town of Washington, 19 miles above Nevada City, was one of the many early settlements that became very populated along the South Yuba River. Of all the early camps booming in the early 1850s—Brandy Flats, Alpha, Jefferson, Gaston, Maybert, Omega, Ormond, and God's Country—only the town of Washington survived. The road from Nevada City leading to it was called Washington Road. In bad winters, snow blocked the road and often isolated the town with access by snowshoes the only means in and out of the town.

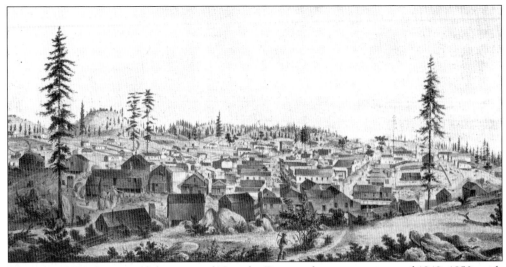

This is an 1851 drawing of the town of Nevada. Despite the severe winter of 1849–1850, with snow falling four feet deep, the summer of 1850 brought an estimated 6,000 to 16,000 people to Nevada City. Like Rome, Nevada is built on seven hills: Piety, Prospect, Boulder, Aristocracy, Buckeye, Nabob, and Lost, as well as Oregon, American, Bourbon, Canada, Coyote, Cement, Manzanita, Phelps, Oustomah, and Wet Hill. (Courtesy Searls Library.)

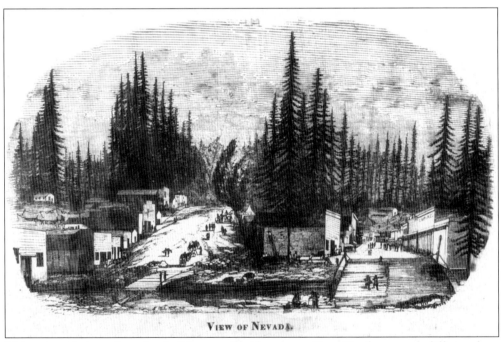

VIEW OF NEVADA.

This postcard view of wooden buildings and bridges across Deer Creek was very different from the 1849–1850 mining camp of canvas tents, wooden and branch shelters, and only a scattering of log cabins. By 1851, Nevada and her sister city Grass Valley were the most populous mining towns in California. With the rich diggings of Coyote Hill and Deer Creek, Nevada became the seat of government. (Courtesy author.)

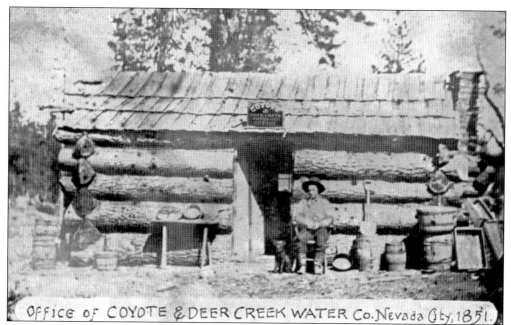

In November 1850, the Deer Creek Water Company began construction of a ditch to bring water from Deer Creek to Nevada starting at the upper end of the creek. The rival Coyote Water Company began their ditch at the end next to the town. The two companies consolidated in the fall of 1851 after continual lawsuits regarding the ownership of water rights. (Courtesy Brita Rozynski.)

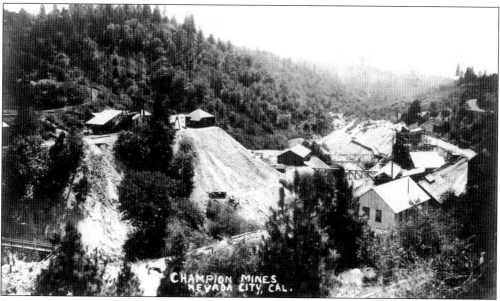

Seen in this popular postcard, the Champion Mine, one and half miles from Nevada City, had extensive surface operations covering 440 acres. The Champion Mine was first known as the New Year's Mine in 1851. It was a rich mine, producing between $8 and $20 million. It was eventually bought by North Star Mines Company. (Courtesy Jan Davis.)

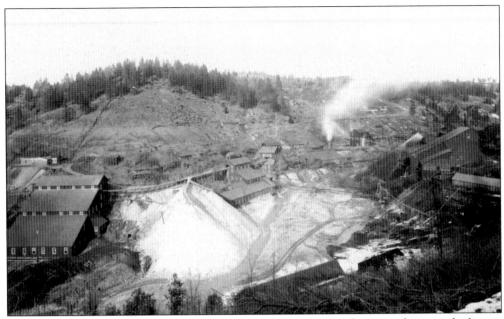

By 1895, the Champion was the leading mine of the Nevada City district and among the largest and most extensive mines in the county. Located on Deer Creek, it consolidated the Wyoming, Merrifield, Merrifield Extension, Climax, New Year's, New Year's Extension, Muller, Phillips, Ural, Relocation, Bavaria, and Mary Ann Mines. (Courtesy Searls Library.)

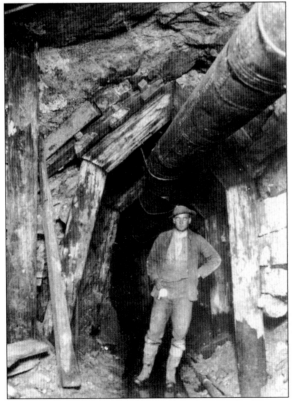

At the Champion Mine, special timbering was needed to accommodate the 20-foot ventilating line through the heavy ground at the 2,700-foot level. The New Year's vein tunnel ran 3,000 feet and had large quantities of free gold—high-grade ore—running through it. (Courtesy Searls Library.)

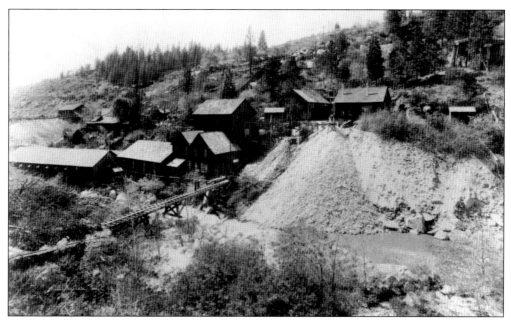

The extensive property of the Mountaineer Mine consisted of 300 acres of lode and placer mines. It adjoined the Champion Mine group holdings on the east. The ore was ribbon quartz and carried free gold and a percentage of silver larger than most mines in Grass Valley and Nevada City. The Live Yankee, Summit, Dodo, and Orleans Extension were all part of the Mountaineer holdings. (Courtesy Searls Library.)

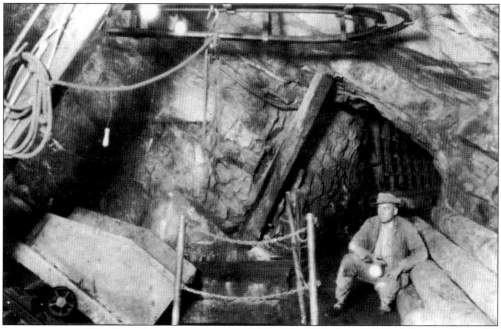

A photograph of the Providence shaft at the 1,700-foot level shows an overhead crane device for handling heavy timber and material. In 1858, the Providence was located on the south bank of Deer Creek opposite the Champion Mine, and the property consisted of 150 acres. It had produced $5 million before it was purchased by the Champion in 1902. (Courtesy Searls Library.)

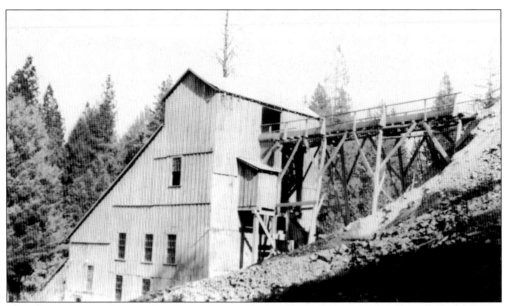

The Gracie Mine, plant, and mill were located south of Nevada City, near the Pittsburgh Mine and Canada Hill. The patent covered 1,500 feet along the Gracie-Glencoe vein. The vein ran through both mining properties. One of the most continuous in the Nevada City district, it joined the Glencoe and ran for three miles. This mine was owned by John Arbogast and went to his estate after his death. (Courtesy Searls Library.)

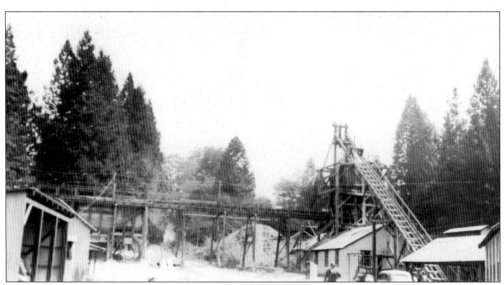

This photograph shows the Cornish pump at the Sneath and Clay Mine in Gold Flat. The Cornish Beam Pumping Engine made it possible for deep mining in Europe and North and South America. By the 1880s, most steam-powered pumps were converted to the water-driven type following the discovery of the Pelton Wheel. To power the steam-driven pumps, each engine burned 44 cords of wood a day. (Courtesy Searls Library.)

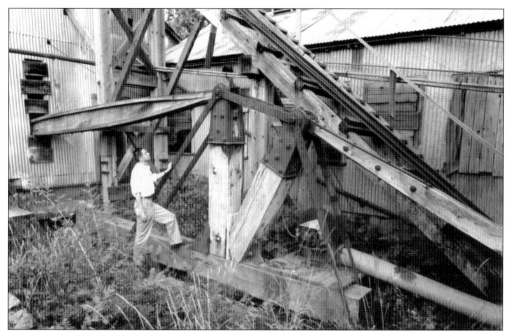

The Sneath and Clay Mine was a large producer in the early days, making $2 million between 1862 and 1865. It closed in the mid-1860s, reopened in 1915, and was sold in 1916 to a Los Angeles investor. It never again reached the riches of the early days, only producing $180,000. (Courtesy Searls Library.)

Once known as the Donner Mine Camp, the Zeibright Mine was a big producer in Nevada County. The miners lived at the camp year-round; single men were lodged in the bunkhouse and married men built log cabins on the property. A fire in 1934 destroyed the surface buildings, including the main cookhouse, bunkhouse, and all their contents along with the winter supply of food and fuel. (Courtesy Searls Library.)

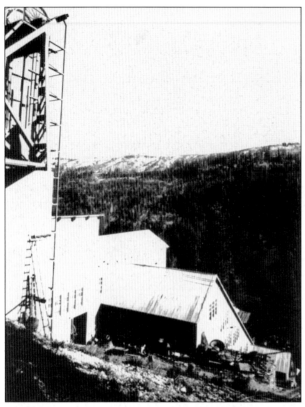

The Zeibright Mine, a very rich producer located at the base of Bear Valley 22 miles east of Nevada City, became part of the Empire Star, a subsidiary of the Newmont Mining Company. During an ordinary winter, the mine would be snowbound for most of the season. Bear Valley was a popular area for camping, fishing, and hunting in the early days. (Courtesy Searls Library.)

Not developed until September 1900, the Zeibright Extension Claim was discovered by the Zeibright Mining Company, owned at that time by James F. Colley, William F. Englebright, Fred Searls Sr., William Griffin, Alex Hongell, E. D. Elastin, and G. M. O'Conner. By 1939, new surface plants opened, a new dry house was completed, and a hotel was constructed. This photograph taken by Jack Clark shows the mine entrance. (Courtesy Searls Library.)

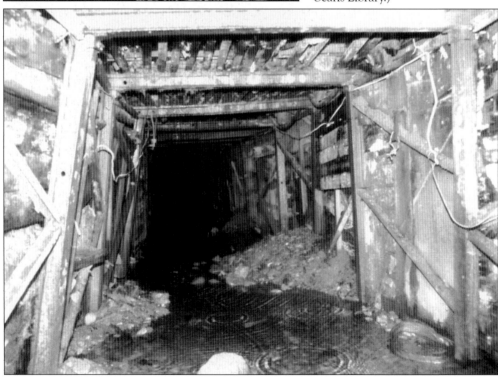

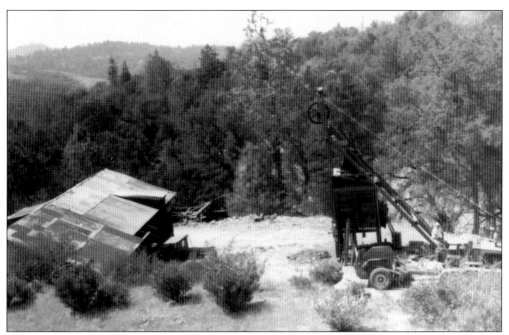

The Aetna Mine resided on the Garesio Ranch at Indian Flat. First patented in 1885 by William F. McDowell, the ranching property was purchased by Valerio Garesio in 1921 to provide a living for his family. The long-abandoned tunnel on the property was explored by the family and, after years of labor, a rich vein was discovered. (Courtesy Joe Garesio.)

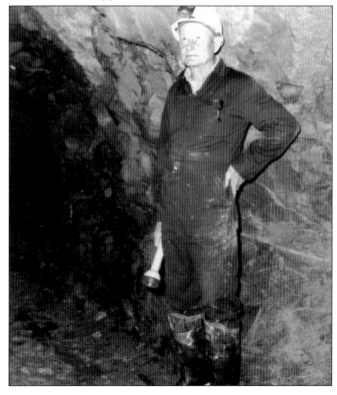

Joe Garesio is checking the condition of the Aetna mine. Joe attended the one-room Indian Flat school and, over the years, worked at the Old Brunswick, Murchie, Golden Center, Stockton Hill, and Coan Mines. At the Old Brunswick, he was a skip tender and, along with superintendent Albert Crase, held the record for hoisting the most rock in a shift. (Courtesy Joe Garesio.)

This undated photograph of the Hoge property in Nevada City shows abandoned ore cars, track, and other parts of mining equipment—remnants of the rich glory days of Nevada County's historic past. It produced over $600,000. (Courtesy Searls Library.)

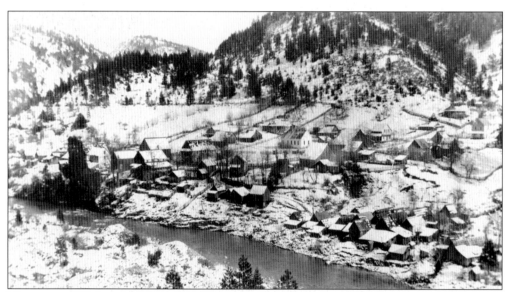

The town of Washington is 19 miles from Nevada City, above the South Yuba River. The early mining camps of Washington, Alpha, Gaston, Gold Hill, Jefferson, Maybert, Omega, Ormonde, and South Fork were located in the Washington district. The Alpha diggings was said to have been one of the richest placer mines in Nevada County. It was the birth place of Emma Nevada, born Emma Wixom, the world-famous soprano and great operatic diva who skyrocketed to fame in Paris, the then musical capital of the world. (Courtesy Searls Library.)

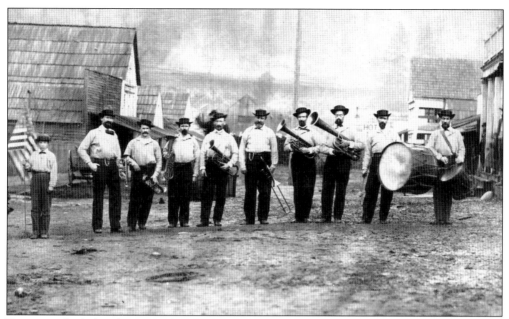

Every town had a band or musical group that performed at dances and celebrations; the Washington Brass Band was formed in 1866. Standing in the road, from left to right, are George Grissel, flag boy; John McKean, saloon keeper; Philip Goyne, conductor and miner; John Goyne, miner; Fritz Meister, miner; Mr. Moulton; Dr H. F. Wilkinson, miner; J. H. Adams, miner; John W. Brown, miner; and unidentified. (Courtesy Searls Library.)

After the early boon, the town of Washington grew into a prosperous burg. Because a more easily accessible road had been built from Emigrant Gap, located near the Central Pacific Railroad, Nevada City merchants were losing business from the Washington area and complained to the board of supervisors. In 1872, the board of supervisors voted to build a road to the town. (Courtesy Searls Library.)

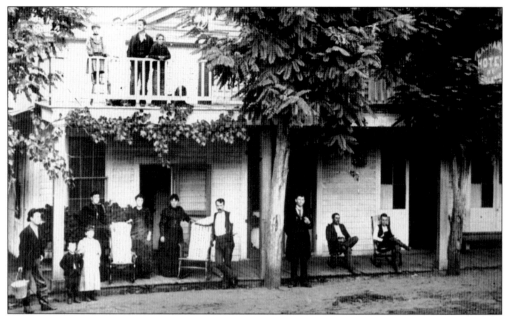

Many small settlements sprung up on the Washington Ridge beginning in the fall of 1849. The first miners appeared along the South Yuba River, camping on the flat where the town of Washington began. Because it was late in the year, the men, all from Indiana, decided to spend the winter there and named the place Indiana Boy's Camp. (Courtesy Searls Library.)

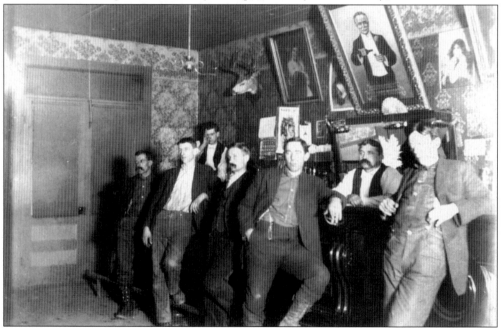

The miners from Indiana Boy's Camp had to go to Nevada City for supplies and mail and talked about their success on the gravel bars along the river. By 1850, the town was bustling with hotels, saloons, businesses, and cabins. This photograph shows the interior of the barroom of the Washington Hotel around 1900. Sheriff and gunfighter Wyatt Earp spent the night of December 20, 1902, at the hotel. (Courtesy Searls Library.)

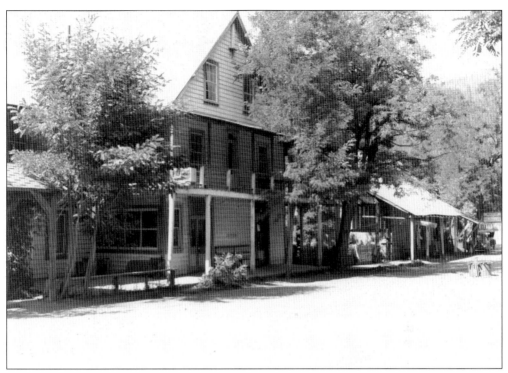

Fires in 1867 and 1896 destroyed two former hotels on the current site of the Washington Hotel, pictured here in the center, on Main Street. The door on the right leads to the barroom. People from surrounding communities would come to town to attend the popular balls and dances held at the hotel. The Worthly family owned the hotel for many years. (Courtesy Searls Library.)

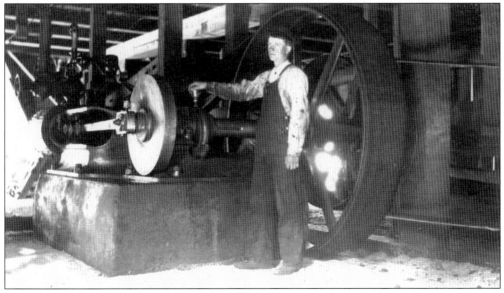

This generator, housed in a barn behind the old Yuba House, may have used water from Scotchman's Creek to power the town of Washington. However, power was phased out in the late 1930s as the population declined, and the town reverted to using kerosene lamps until 1944, when PG&E supplied power to the newly built Tahoe Sugar Pine Lumber Mill. (Courtesy Searls Library.)

Part of two old mine buildings or cabins remain above Canyon Creek, which runs from the Bowman Reservoir to the South Yuba River between Poorman's Creek and Fall Creek and passes under the old Maybert Road. Canyon Creek, one of the deepest and most inaccessible streams in Nevada County, was second in size only to the South Yuba River, into which it emptied. (Courtesy Searls Library.)

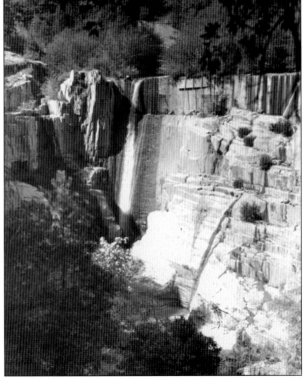

Water is running over the slit dam on Scotchman Creek in this 1942 photograph. It was constructed to keep the mine tailings from going into the Yuba River. Hydraulic mining was still practiced in Nevada County on a small scale after World War II and through the 1950s. (Courtesy Searls Library.)

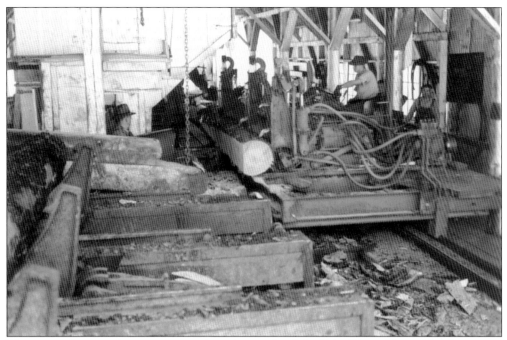

There were large timber reserves on the ridge south of the Yuba River. The gold rush town of Alpha was built with lumber unlike the hastily built camps and towns of canvas, brush, and clapboards. There were prosperous lumber mills above the town in the early days, and the town had a cheap supply of lumber. (Courtesy Searls Library.)

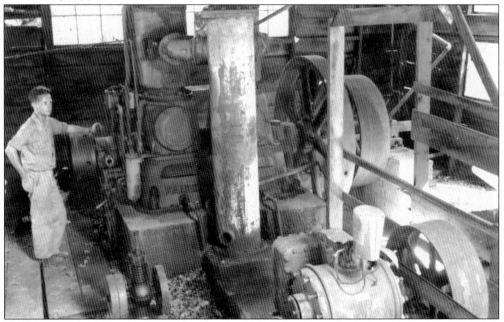

The Red Ledge Mine was off the Nevada City road, three miles from the town of Washington. By 1918, this mine yielded several hundred tons of fine-grade chromite ore. The Washington mining district produced gold, chromite, and asbestos. Chromite was in great demand during wartime. (Courtesy Searls Library.)

Pictured here are members of the Isabel Williamson family, early settlers of the town of Washington. The Williamson children were William, Richard, James, Grace, Hector, and Thomas Bruce. Two of the brothers, Hector and Richard, along with Clyde Cole, were the founders and owners of the famous Red Ledge Mine. (Courtesy Searls Library.)

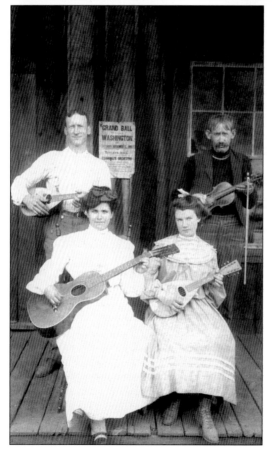

The handbill posted on this building announces the Grand Ball in Washington on Saturday September 17, 1904, at Kohler's Hall. Thomas Bruce Williamson, left, worked at the Red Ledge, a California mine famous because of its rich, crystallized gold. The Smithsonian in Washington, D.C. has a specimen from the mine that is four inches in diameter, one of the largest ever found. (Courtesy Searls Library.)

Seven

ROUGH AND READY
AND SPENCEVILLE

By 1856, Rough and Ready was the third largest town in Nevada County behind Nevada City and Grass Valley. Located four miles below Grass Valley, the town was founded by a company of men who had crossed the plains together, traveling over the Truckee Pass to arrive on September 9, 1849. Named for the company of men who were called the Rough and Ready Company in honor of their leader, Capt. A. A. Townsend, who has served under Gen. Zachary Taylor in the Winnebago War, Rough and Ready soon mushroomed into a mining camp and then quickly became a town. Others in the group included Reverend Pope of Iowa, Putman and Carpenter from New York, and Peter Vanmetre, Colgrove, Hardy, Dunn, and Richards, all of Wisconsin.

In 1850, E. F. Brundage conceived the idea of making Rough and Ready a separate and independent state. A meeting was held, but as his proposal was met with ridicule, the idea was dropped and soon forgotten. This is not the popular legend, but historians and writers believe it to be correct per the *1880 History of Nevada County*.

On June 28, 1853, a fire destroyed the business district, and on July 8, 1859, high winds spread a fire that consumed the whole town. It would take decades to recover, but it would never be the bustling town it was in the 1850s.

Being at a lower altitude than other areas of Nevada County, Rough and Ready saw a steady growth in agriculture and ranching. It was also on the road that led to Marysville in Yuba County, the original parent county that Nevada County was created from in 1851. This would help to keep the businesses operating even though most of the townspeople moved elsewhere after the two fires and mining slowed in the district.

Copper discoveries in and around the area that became the town site of Spenceville caused great excitement in 1865 and 1866, and thousands rushed to take up copper mining claims. The towns of Spenceville, Hacketville, Wilsonville, Queen City, and others were laid out, but only Spenceville remained after the rush was over and the majority of people abandoned the claims.

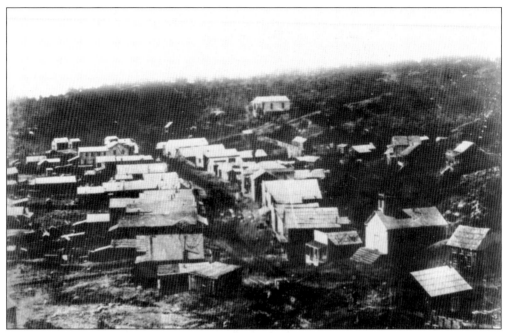

It has been said that a member of the Rough and Ready Company found gold when the company stopped so he could get a drink of water at a stream. The company moved the camp and sent a wagon on down the valley to Sacramento to bring back supplies. The above photograph shows the center of town in 1857. (Courtesy Searls Library.)

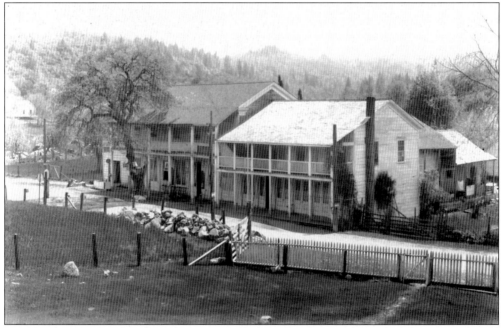

In 1850, there were only a few cabins scattered about the area until April of that year. The old Donner House, popularly known as Rough and Ready Hotel, was a stage stop on the road between Marysville and Grass Valley. It was dismantled in 1949. Built on the old site was a new "town and country" type building for retail business. (Courtesy Searls Library.)

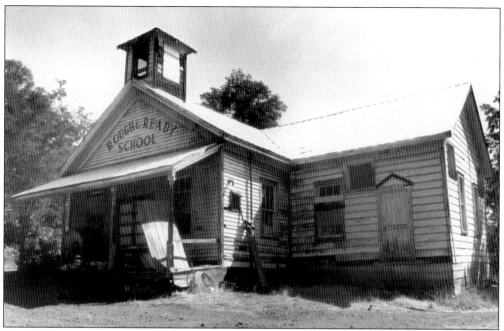

The first school in Rough and Ready was private and closed soon after its 1851 opening. A second school began in 1853 but closed when the first public school opened. In 1868, the Rough and Ready School District was established and a public schoolhouse built. This building stood until the massive Trauner fire on August 7, 1994, destroyed it. (Courtesy Searls Library.)

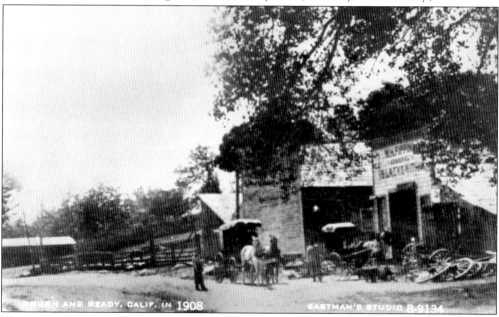

The town of Rough and Ready declined as the gold interests in that district weakened. During the 1870s, there was great excitement when the Japanese embassy sent representatives to look at the town. Improvement of the lots on the mined-out ravine began, and the people, who had become a little pretentious, planned to complete a new hotel in time for the arrival of the ambassador. (Courtesy Searls Library.)

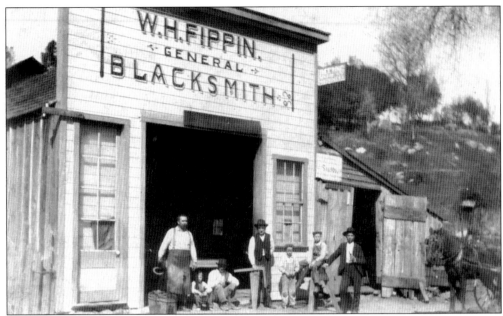

Son of pioneer parents, native-born William H. Fippin was one of 10 children born to Johan and Julia (Single) Fippin. He followed his father's trade as a blacksmith, and their blacksmith shop was the busiest place in town. This photograph shows Charlie, George, Marion, and Jim Single with W. H. "Bill" Fippin and possibly his nephews, as Bill Fippin never married. (Courtesy Searls Library.)

Frank Allen came as a slave from the plantations of the South and worked in the Slave Mine, owned by Abel Porter and Col. William English, on Deer Creek between Rough and Ready and Newtown Mine. Allen's daughter Caroline is said to have planted a tree when she came into town and stuck a cottonwood switch in the wet ground. (Courtesy Doris Foley Library.)

This photograph shows harvesting at Bucks Ranch. Nevada County's mild climate and rich soil enabled farmers and ranchers to produce a large variety of agricultural products, including hay, wheat, and grapes, and citrus, apple, pear, and peach orchards. Fruit was packed, shipped out by the NCNGRR, and then loaded onto the cars of the Central Pacific headed east. (Courtesy Searls Library.)

The Cyrus Bittner family, early pioneers in Spenceville, came to California after the Civil War; Bittner was a veteran. His daughter Ella May married John Austin, son of another pioneer family. Ella Austin became the first female superintendent of schools in Nevada County and held that office from 1922 to 1933. The post office is the building on the left. (Courtesy Searls Library.)

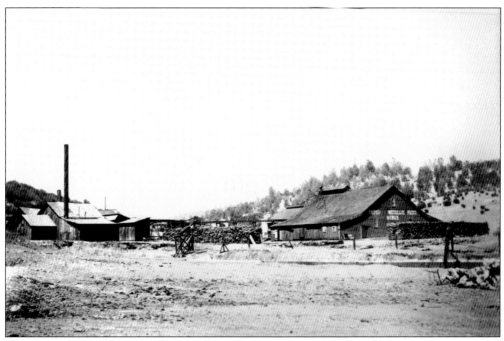

The Imperial Metallic Paint Works produced a paint that would later be known for eating the heads off nails in buildings where the paint had been used. The town of Spenceville was located in the rich copper region known for its copper ore. Cyrus Bittner was a mine owner with large copper interests. (Courtesy Searls Library.)

As the town of Spenceville grew, a hotel, school, post office, and stores were built. August Anderson's house and general store are pictured to the right of center with the white picket fence. Farther up the hill is the Spenceville schoolhouse, and behind the large tree in the center was Ella May Austin's house. A wagon team sits under the porch of the store. (Courtesy Searls Library.)

Eight

RED DOG, YOU BET, AND CHICAGO PARK

The towns of Little York, Red Dog (Brooklyn), You Bet, Hunt's Hill (Gouge Eye), Walloupa, Chalk Bluff, and Lowell Hill grew out of mining camps that collectively became Little York Township. The first mining in the area was prospected in 1849, but it was not until the fall of 1851, when deep diggings were discovered in several areas, that excitement ensued. Towns sprang up and populations soared for a time. When claims failed to pay, corporations started buying up the smaller holdings and the population declined. Several of the towns burned to the ground with heavy losses, and most of the business owners and miners left the area.

As the placer claims of the early days gave way to hydraulic mining, water became a major issue in this district. Those who were able to bring water into remote areas through ditches and flumes made high profits by selling it to miners. But several competing companies found that water development in rugged terrain was expensive. Diverting water also caused problems for anyone who had a claim, dam, or flume downstream, and resulting lawsuits made many lawyers wealthy. Eventually, to resolve the issues of water ownership, the companies bought each other out or merged.

The area that became Chicago Park was known as Storm's Station for almost four decades, named for early settler and former Indian agent Simmon Seña Storms, who had a ranch and trading post in the area near present-day Chicago Park. In 1887, a company from Chicago, Illinois, purchased land to start a colony four miles from Colfax. The site was situated on the line of the Nevada County Narrow Gauge Railroad, and 80 acres were set aside for a town site. The company divided the first acreage they purchased into town lots and 20- and 40-acre tracts for farming and ranches.

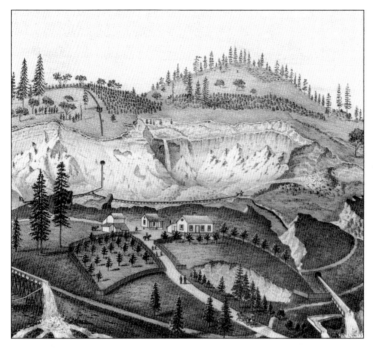

From the *1880 History of Nevada County*, this drawing shows the residence, gravel gold mine, and part of the 500 acres that John Hussey owned, located east of Red Dog and west of Chalk Bluff. The Irish immigrant became a rancher and miner with mining interest in other parts of the county, including the Franklin Mine at Willow Valley and the Tiger Quartz Ledge in Washington Township. (Courtesy author.)

Chalk Bluff was two miles away from its rival town of Red Dog, pictured here above the Hussy Mine. On the banks overlooking Red Dog, the name Chalk Bluff came from the range of low bluffs whitened by the exposed channel of the Big Blue Lead. The town of Dutch Flat in Placer County was just a few miles east of the Hussy Mine. (Courtesy Searls Library.)

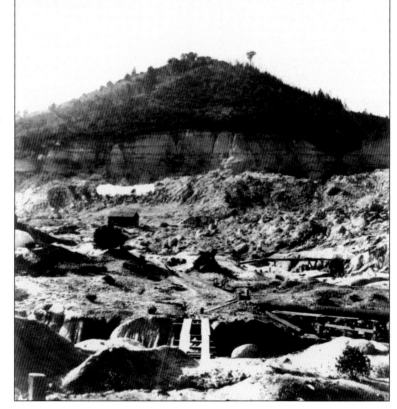

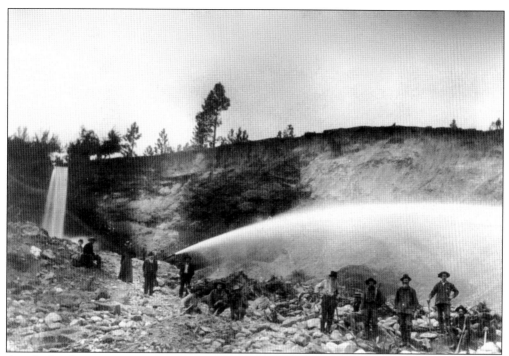

At a hydraulic mining operation at Red Dog in 1892, water is coming down the hillside to a reservoir. There would have to have been a debris dam in order for legal hydraulic mining to operate after the Sawyer Decision. (Courtesy Searls Library.)

You Bet, once one of the liveliest towns in the county, had a population of over 4,000 in 1863. One story has the town being named was for the California idiom "You Bet," uttered so frequently in the early camps and towns of the gold rush where gambling was only second to mining as an industry. A pipeline brought water through the town. (Courtesy Searls Library.)

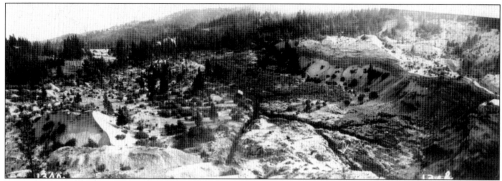

In 1850, Henry Stehr, Joseph Chow, and Charles Wilson, all under 22 years old, ventured into the wilderness. Stehr and Chow, who had lived in Arkansas, named the nearby ravine after their home state. They gave the honor of naming the hill to Wilson, the youngest member of the group at age 15. The name Red Dog Hill was chosen after a zinc mine of the same name. (Courtesy Searls Library.)

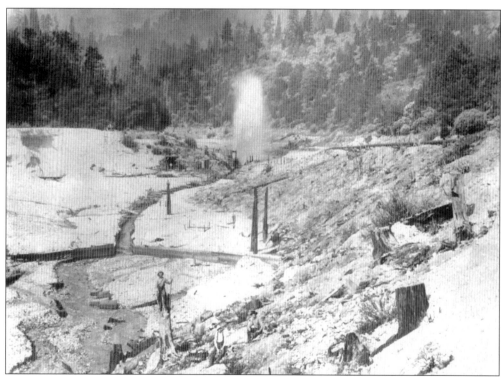

Another story states that the town of Red Dog was named after a miner who had a dog with a reddish coat or that the name came from the reddish soil that is prevalent in Nevada County. Whatever the true story, the name was in place by 1852 and has not changed. This photograph shows an unidentified miner in Red Dog. (Courtesy Searls Library.)

Harold ? stands in Greenhorn Creek. In 1855, Greenhorn Ditch took water from the creek eight miles above Red Dog and brought it down the opposite side of the stream for use in mining claims and households. It supplied McCloud's Ranch, running six miles over auriferous dirt, which paid largely to whoever prospected it. It was said to be one of the best constructed ditches in the county at the time. (Courtesy Searls Library.)

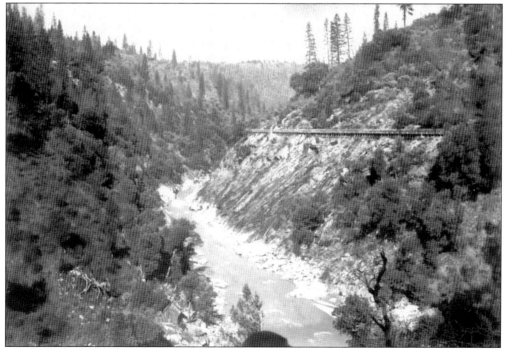

Pictured above, a flume runs high above the creek. It could be the one that ran to Brown's Hill and other hydraulic diggings or the Greenhorn Ditch that ran to You Bet. The You Bet hydraulic mine that had been idle for 10 years started back up in 1898. The dam constructed to hold the debris cost $2,000. (Courtesy Searls Library.)

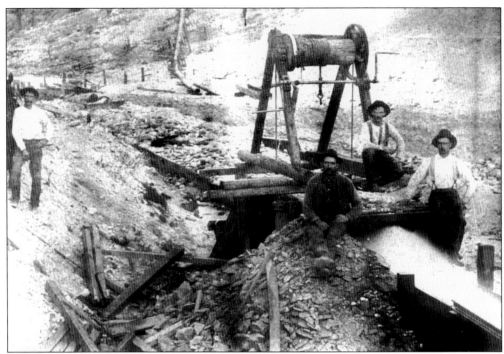

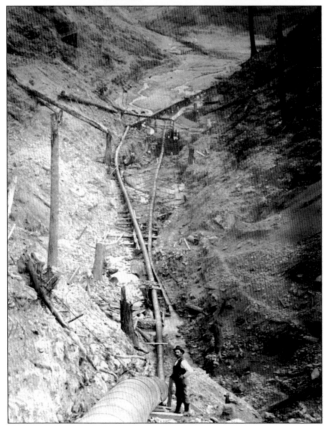

Identified in this photograph are Jerry Goodwin, sitting on the slag pile, and Jack Kahill at far left. In 1903, Goodwin was involved in a quarrel when he shot Tom Blue, who was beating him, and Blue died as a result of the wound. Goodwin was also involved in a possible double murder in 1913 in which both Goodwin and Leroy Clark died believing they had shot each other. (Courtesy Searls Library.)

Jerry Goodwin was a big mine owner in You Bet. After his death, an inventory was taken of all his property, but only a very small amount of gold was found. Goodwin owned 850 shares of capital stock in the Gilmore Airship Company, a corporation of Lyman Gilmore, a local airplane inventor who was said to have flown in Nevada County before the Wright Brothers. (Courtesy Searls Library.)

Nine

Up-Country Towns

Up-country designates the area beyond Nevada City farther up the foothills into higher elevations. The region around San Juan Ridge and its surrounding towns made great contributions to the history and economy of Nevada County in the early days. From the first long-distance telephone call in the United States to immense gravel mining operations, they were of great importance to California's 19th-century California economy. (North San Juan is actually in the Bridgeport township.)

By the 1860s, hydraulic mining was common in the northern mines. The hills of San Juan Ridge were blasted away with water traveling through large hoses and nozzles at a rate of 150 feet per second. Mud and rocks shot over 500 feet into the air. The resulting runoff caused debris and silt to flow down to farmland and waterways in the lower valleys. This became known as the battle of gold versus green.

In 1878, three companies on the ridge joined together to build the first long-distance telephone line in the world. Eureka Lake and Yuba Canal Company, the Milton Mining and Water Company, and the North Bloomfield Mining Company built a line extending 60 miles from French Corral with connections at North San Juan, Tyler, North Columbia, North Bloomfield, Moore's Flat, Graniteville, Milton, and Bowman Lake.

The Sawyer Decision in 1884 severely limited hydraulic mining and greatly affected the majority of the up-country gravel mines. Miners and their families left or turned to ranching, and towns, such as Meadow Lake (Summit City), once a populous community where now not a stick of wood remains, steadily declined. Meadow Lake Township included the towns of Boca, Hobart Mills, and Truckee.

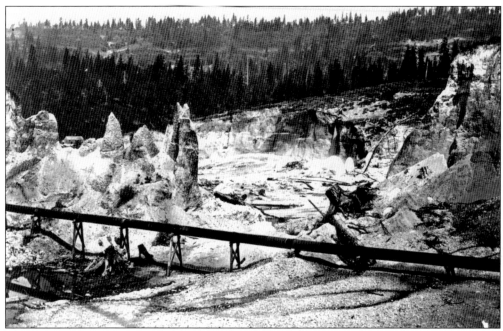

This iron pipe brings water to the North Bloomfield Gravel Mine. The North Bloomfield was once one of the largest, if not the largest, producer of the gravel mines in Nevada County. Its usefulness was marred by the Sawyer Decision in 1884. In 1898, it employed about 40 men who were hydraulic mining and depositing the debris behind retaining dams. (Courtesy Searls Library.)

This c. 1900 photograph shows the general store of McKilliean and Mobley. Born in Sweetland, Walter Leon Mobley later lived at the Malakoff Mine where his parents operated a boardinghouse. He went to work for Crandall and McKilliean as a teenager. He moved to Nevada City in 1922 and served as justice of the peace and judge for 12 years. (Courtesy Searls Library.)

Here is an undated photograph of Main Street in North Bloomfield. On November 12, 1887, a fire broke out in the store of O'Connell and Morrison, which quickly spread to Mrs. Edward's hotel, the saloon of Blivens and Silverster, and Marriott's Variety store, destroying all the buildings and stock. Luckily the firefighters prevented the fire from spreading to the other buildings on Main Street and destroying the whole town. (Courtesy Searls Library.)

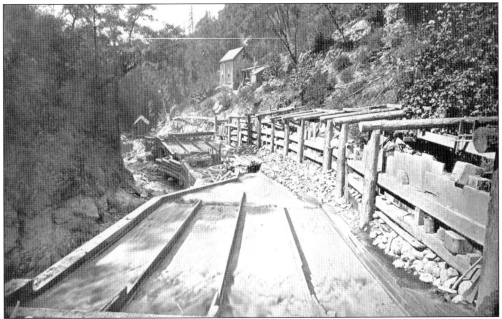

This photograph shows the fast-flowing water (undercurrents) coming from the tunnel of the North Bloomfield Gravel Mining Company, completed on November 24, 1874. Water from the mountains was carried from the mine to the South Yuba River. The escaping water ran over aprons that carried the fine gold. (Courtesy Searls Library.)

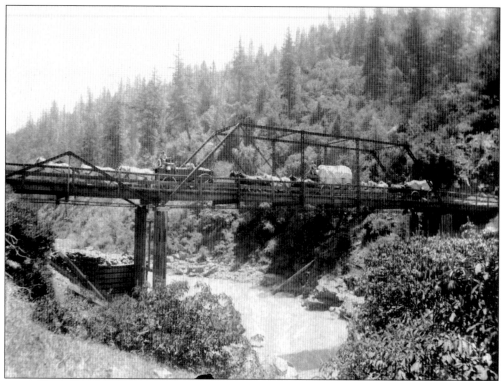

Edward's Crossing, one of the most important bridges in the region, was located on Bloomfield Road. In 1852, the bridge was known as Robinson's Crossing, and as later Webber's Crossing, Wall's Bridge, and Black's Bridge. By 1880, it was owned by William Edwards, and early toll for this bridge was $3 for 8 horses, 75¢ for a horse-and-buggy, and 25¢ for animals. (Courtesy Searls Library.)

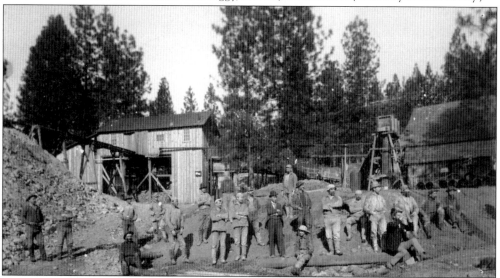

The ridge lying between the middle and south forks of the Yuba River contained the richest deposits of auriferous gravel found in California. The Derbec was one of the oldest and largest mines on the Washington-Omega channel. Even after the Sawyer Decision, it continued to operate and was paying expenses and an occasional small dividend. (Courtesy Searls Library.)

Wells Fargo and Company not only carried gold and valuables but something that was almost more important to the early mining camps and towns—fast delivery of the newspapers from the East, San Francisco, Sacramento, and Oregon. This was the Wells Fargo and Company office in North Bloomfield. A stage robbery in 1855 was the second one the company suffered in six months, totaling $35,000 in losses. (Courtesy Searls Library.)

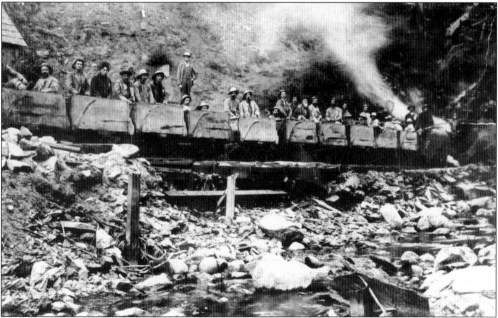

A small railroad was constructed at the Union Blue Mine in North Bloomfield. In 1902, the North Bloomfield Mining Company constructed a flume one and a half miles in length to carry 500 inches of water to the Union Blue, Gaston Ridge, Plumbago, and Malakoff Mines to furnish power to the machinery and run the dynamos, which were temporary while the ditches were being repaired and enlarged, at the Plumbago mine. (Courtesy Searls Library.)

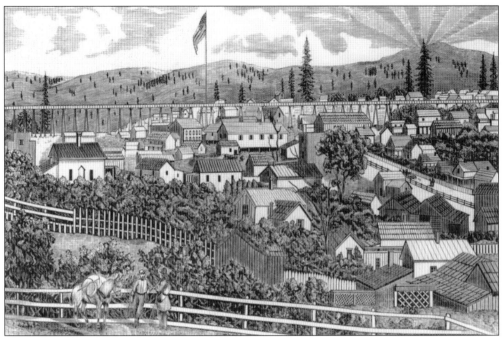

The original name of the town of North San Juan was San Juan, seen here in the drawing by 1870s artist Charles Nahl. In 1853, Christopher Kentz, who discovered the diggings, and Edward A. Skiff built a cabin before leaving for Sweetland. Turning to look back, Kentz remarked that it looked like the Castle of San Juan. When leaving Sweetland to come home, the men joked, saying they were going to San Juan. (Courtesy Searls Library.)

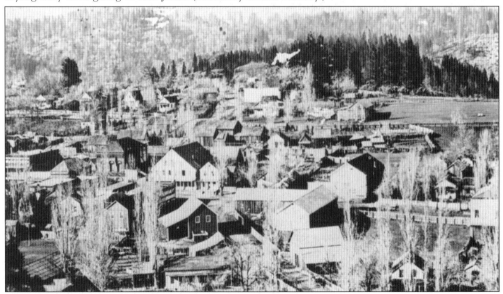

By the late 1850s, San Juan had over 50 businesses. The most unusual feature of the town was the flume running through the middle of it. The ridge of San Juan is named after the town, located between the south and middle forks of the Yuba River. The name was changed to North San Juan because there was another town that already claimed the San Juan name. (Courtesy Searls Library.)

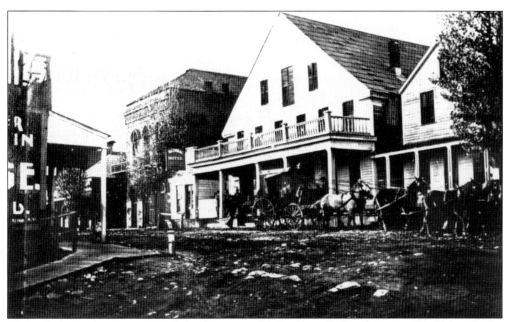

The 1850s were boon years, and the towns on the San Juan Ridge grew rapidly. Although the ridge towns were nearer to Marysville, the merchants chose to trade with the business house in Sacramento because of better prices. The National Hotel in North San Juan had no affiliation with the hotels of the same name in Nevada City or Auburn. (Courtesy Searls Library.)

North San Juan businessmen, pictured here around 1880, from left to right, are (first row) E. Northrup, constable; unidentified; Jack Ray, farmer; O. P. Stidger, lawyer and editor of *NSJ Times*; Daniel Furth, merchant and banker; James Chisholm, butcher and general merchant; and Louis Buhring; (second row) Jason A. Stidger, lawyer; William Menner, Menner and White Hardware; John Hill, farmer; John German, proprietor of hotel; and Charles Schenerman, bakery and saloon. (Courtesy Searls Library.)

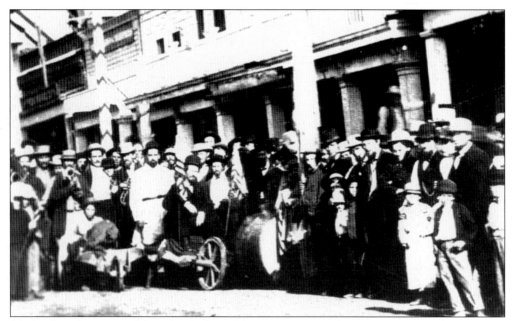

The earliest documented Fourth of July Celebration found in the extant local newspapers were the festivities held in North San Juan in 1858. A number of the residents would venture down to Nevada City and Grass Valley to join family and friends in their large annual celebration. This photograph of North San Juan dates to 1860. (Courtesy Searls Library.)

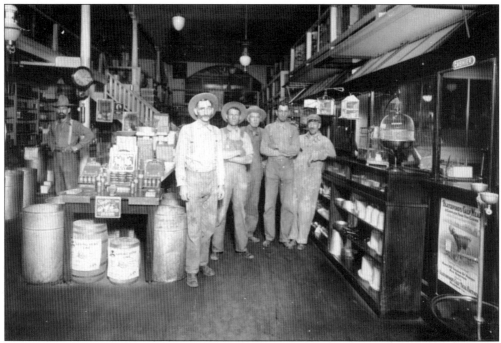

Back in the decades when the San Juan Ridge was the scene of some of the world's most spectacular hydraulic mining ventures, businesses in North San Juan were prosperous, while neighboring ridge mining towns declined almost as quickly as they mushroomed. North San Juan survived and is again a growing community in the up-country. (Courtesy Searls Library.)

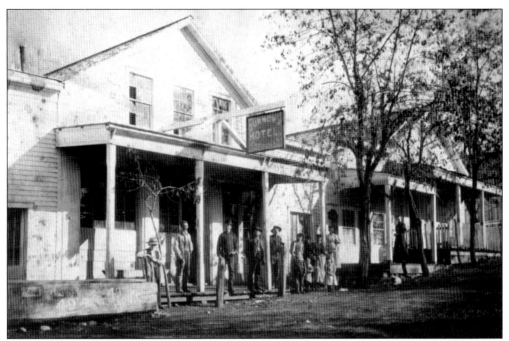

This town was originally known as Cherokee and was named according to the *1880 History of Nevada County* for a little stockade hut built by some Cherokee Indians who mined there in 1850. In 1852, the population was 400. Postal authorities established a post office in 1855 and named it Patterson and the town took on that name until the post office was discontinued in 1895. This was repeated when it was reestablished in 1905 but was again discontinued in 1909. (Courtesy Searls Library.)

By 1867, the thriving town of Patterson (still called Cherokee by many) had a Catholic church, several stores, two hotels, a shoe shop, a blacksmith, and a sawmill. The name was again changed in 1910 when a post office was reestablished with the name of Melrose, but the name was changed to Tyler that same year only to be discontinued in 1924, when it again took the original name of Cherokee. (Courtesy Searls Library.)

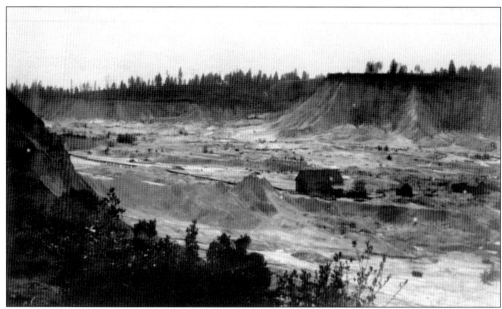

Eureka Lake and Yuba Canal Company joined to form the Rivers Mines Company, which had claims in the French Corral, North San Juan, Columbia, and North Bloomfield Mining districts. The Badger Hill and Cherokee Mines were placer mines in North Columbia. The undated photograph above is the gravel mine at Cherokee, and the owner was George W. Starr of Grass Valley. (Courtesy Searls Library.)

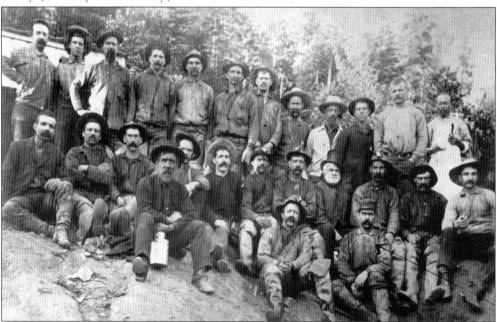

This 1887 photograph of miners at the Rocky Glen Mine was taken in Graniteville, 30 miles east of Nevada City. The Rocky Glen consisted of four claims—the Stacey, Illinois, Annie, and Russell Ravine, all with veins of the same names. The quartz from this mine was termed "ribbon rock," as it was light blue in color with bright gold and some silver running through it. (Courtesy Searls Library.)

Gaston Ridge was located between Canyon Creek on the east and Poorman's Creek on the west; no one knows how the town or ridge got their name. The area's heavy snowfall in the winter caused the school there to be open only six months of the year. The road from Gaston to Graniteville was shorter than the road from Gaston to the town of Washington. (Courtesy Searls Library.)

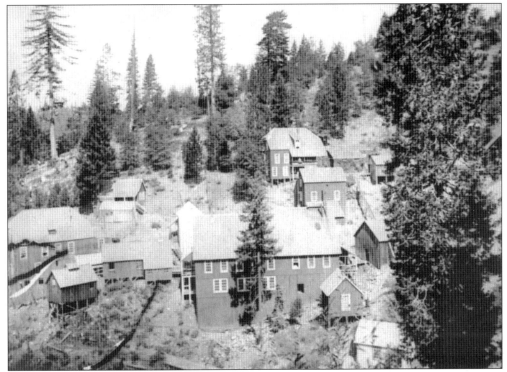

Due to the heavy snow and hard winters, there were many two-story buildings constructed in Gaston, which was unusual for a town so small but a necessity. There was a large boardinghouse and several bunkhouses, a hotel with a saloon, and several stores. A number of the miners were seasonal workers. (Courtesy Searls Library.)

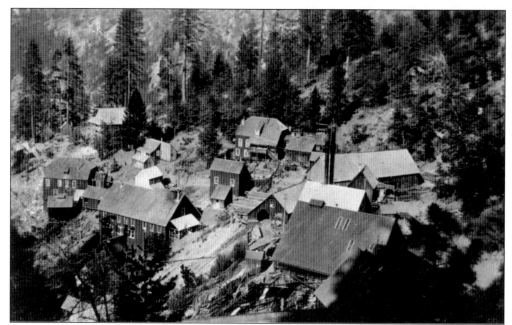

Although sequestered high in the mountainous region above Washington, Gaston had an unlimited supply of wood from the forest surrounding it and water from the North Bloomfield ditch. The town was settled around 1853 by miners and lumbermen on the mountainous slopes at elevations between 5,000 and 6,000 feet. By 1900, the population was only 200. (Courtesy Searls Library.)

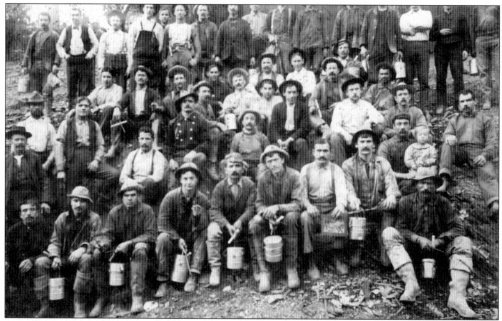

In 1896, the Gaston Mine began construction of a new 4,000-foot tunnel from Poorman's Creek that would take three years to complete. By 1904, the Gaston Mine, the largest employer, consisted of 1,200 acres. The miners worked 10 hours a day and the mill men 12-hour days, which could be the reason the population dwindled. (Courtesy Searls Library.)

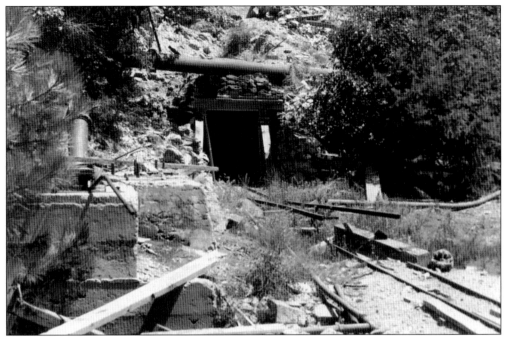

The quartz vein at the Gaston Mine was as much as 15 feet wide in places, and the ore contained both free gold and varying amounts of auriferous sulfides. A nine-stamp mill was built before the ledge opened because of the great promise it showed. The Gaston Mine produced about $2 million between 1898 and 1907. (Courtesy Searls Library.)

This photograph, taken in 1941, shows remnants of the only remaining building at the original town site of Gaston. The harsh winters, with their heavy snow loads, and time have taken their toll on the town. (Courtesy Searls Library.)

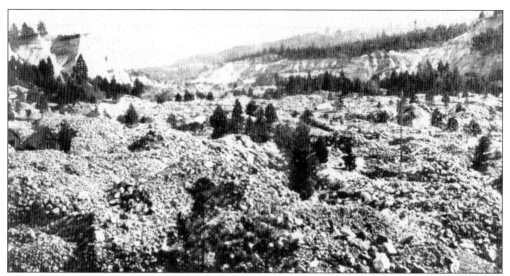

This photograph shows the mine tailings at Moore's Flat, once a bustling town named for Hiram Mark Moore, a pioneer who crossed the plains and arrived in the area in 185. He opened a store and later a hotel. In 1852, the population was 500. In 1859, Moore ran for county judge against David Belden and lost by one vote. (Courtesy Searls Library.)

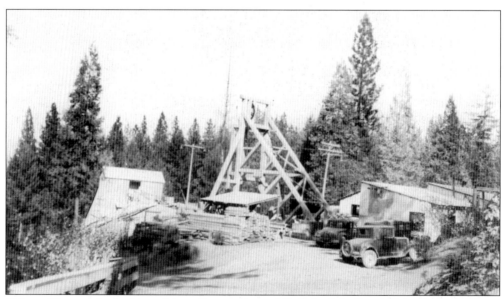

Orleans Flat was the farthest of three flats on the middle fork of the South Yuba River. Gold was discovered there in 1851 at the same time Moore's Flat and Woolsey Flat were settled. In 1862, the population of Orleans Flat was 600, and the town had several hotels and saloons, both important in early mining communities. When the town declined, most residents and businesses relocated to Moore's Flat. (Courtesy Searls Library.)

Pictured is the Boca Hotel, c. 1890, in the town of Boca. Once the terminus of the Boca & Loyalton Railroad, the town lies along the Truckee River. Two flourishing businesses were the Boca Mill Company and the Union Ice Company. During the summer, the workforce at the ice company supplied ice for the fruit cars and shipped ice on the railroad. (Courtesy Searls Library.)

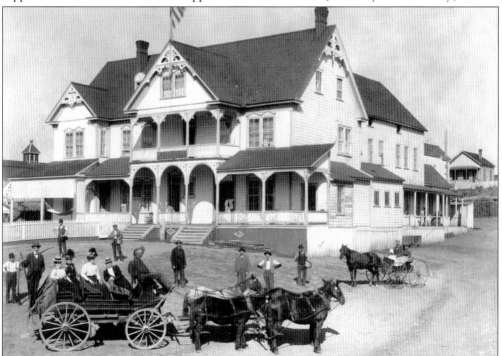

The Boca Hotel and Independence Lake Store, pictured here around 1890, became a popular resort and offered fly-fishing in the neighboring lakes, streams, and river. The hotel burned in 1904 and was rebuilt, although not as grand as the old Victorian one pictured above. Only three items were saved from the hotel—a piano and two slot machines. (Courtesy Searls Library.)

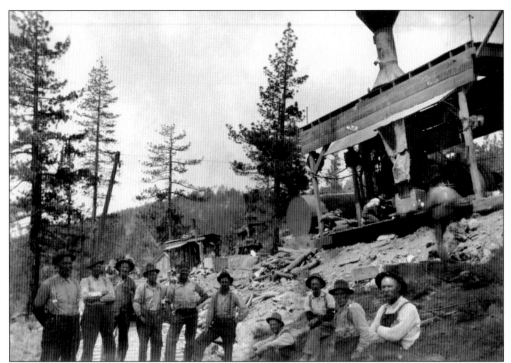

Logging was a large industry in Nevada County as seen in this photograph of the Hobart Mills Lumber Company around 1919. It supplied lumber for the railroad and timber for the mines. From 1867 to 1880, the lumber cut from the Truckee basin provided about five million board feet, which was used to build 35 miles of snowshed. Stanley A. Sanders is the fifth man from left, the only one identified. (Courtesy Searls Library.)

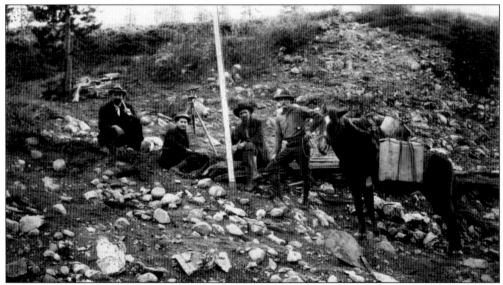

Summit City (Meadow Lake) was located on the west side of Meadow Lake at an altitude of 7,300 feet. The roads were nearly impassable for a large portion of the year. Timber was abundant in this district, and lumber was the largest industry. Prospectors are posing here on English Mountain near the site of the extinct Summit City. (Courtesy Searls Library.)

Ten

INTERESTING FACES, INTERESTING PLACES

Many ordinary people who came to Nevada County became extraordinary citizens, responsible for shaping and building California. Their abilities and talents were given room to shine in a very exceptional place and time—the 19th-century West. This last chapter captures moments in time, the interesting faces and places of the early gold rush mining camps and towns, and the people who were born, lived, married, worked, and died in Nevada County.

California gold made a tremendous contribution to the nation's growth and power, but those benefits came at the expense of the efforts of many. Even though some lucky men in the early years were able to find large quantities of gold without much effort, generally the quest for gold was a hard way to make a living. Discounting sickness and death on the way to the goldfields, many lost their lives in mining accidents or diseases contracted from working in the mines. Others lost their lives by the hands of others, downed by a gun or knife, robbed, or killed in drunken rages at a time before law and order was in place and most men carried deadly weapons. The West was partly civilized by the increasing presence of women and children, and as they arrived, the mining camps transformed into towns, no different from the frontier towns in other states.

Cornishman Edwin Nettell worked at the Slate Ledge and later the Allison Ranch Mine. After saving enough money, he wrote to Elizabeth Ellery in Cornwall asking for her hand. She arrived in 1883, and they were married. Pictured, from left to right, are (first row) unidentified friend of Frederick, Elizabeth Ellery Nettell, and Edwin John Nettell; (second row) Frederick Ellery Nettell, son of Edwin and Elizabeth. (Courtesy Brita Rozynski.)

William Henry Berryman was born in St. Ives, Cornwall, and was employed at the North Star Mine and other mines in Grass Valley. Here the Berryman family poses in front of their home at 417 South Auburn Street in Grass Valley. Pictured, from left to right, are (first row) Clarence, Edith, and Elmer; (second row) Anne, William Henry, and Catherine Ann (Best); (third row) Lizzie, William John, Jane, Sam, Ellen, and Edwin. (Courtesy Brita Rozynski.)

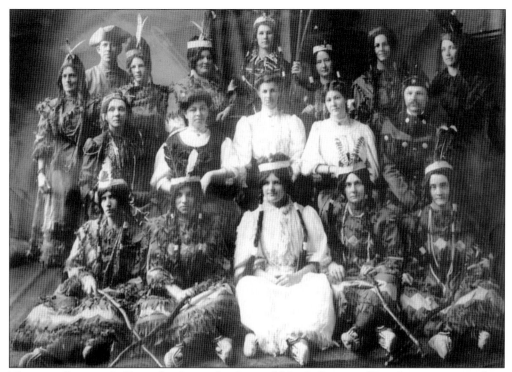

This installation of officers for Ceanotha Council No. 9, Degree of Pocahontas, occurred on January 6, 1906. Deputy Great Pocahontas Minnie Williams installed the following officers: Carrie Nettell, Clara Plank, Edwin Nettell, Jennie Brockington, Mamie Thompson, Lizzie Rawling, Belle Hosking, Lylie Stevens, Ada Wasley, Lydia Nettie Eddie, Lyle Delbridge, Jennie Gluyas, Mrs. Halsall, Flora Abraham, Belle Morgan, and Emily Jenkins, (Courtesy Brita Rozynski.)

Margaret "Maggie" Morrisey, born in 1846 in Ireland, ran a boardinghouse in Virginia City, Nevada. There she met Richard Hicks, a gold miner from Cornwall. She worried what her parents would think of her marrying "an Englishman." However, they married, moved to Grass Valley, and lived at Hills Flat. (Courtesy Gage McKinney.)

Richards Hicks, one of the "old Idaho miners," worked at the Idaho Mine during the regime of the Coleman brothers and then at the Idaho Maryland after the mines combined. Born in 1839 in Redruth, Cornwall, he followed his older brothers to the New Almaden quicksilver mine near San Jose. While working in Virginia City, Nevada, he married Margaret Morrissey. (Courtesy Gage McKinney.)

This is a wedding portrait of Esther Roberts and Richard John Tremaine, who were married on November 1, 1899, at the Nevada City home of the bride's parents, Esther and Stephen Roberts. A home was built for them by their parents in Nevada City at 207 Tribulation Trail on Piety Hill. (Courtesy Brian Suwada.)

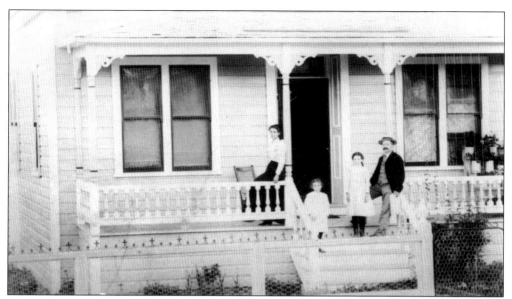

Pictured here around 1898 at the Crase home at 148 Conaway Avenue in Grass Valley, from left to right, are Grace (Hosking), Emillie, Ethel Pear, and Thomas Crase. A third daughter, Laverne Alice, was not yet born at the time of photograph. Crase worked as a gold miner at the Empire Mine and was active in the Mine Worker's Protective League and Knights of Pythias. (Courtesy Bev and Bob Hailer.)

Selina Bice was the first white child to be born in Grass Valley on August 15, 1853. At the time of her birth, there was a big celebration in the mines and the miners showered the mother and child with gold dust. She married Simeon R. Wilder on May 1, 1870, in Grass Valley, and three daughters and one son were born to the couple. (Courtesy Doris Foley Library.)

This photograph of James Moore was taken in 1889 in Virginia City, Nevada, before he married and moved to Nevada City to become foreman of the Champion Mine. Moore died on July 19, 1909, of miner's consumption in Oakland, California, where the family had moved the year before in hopes that his health would improve. (Courtesy Jan Davis.)

James Moore and his family lived in the former William Morris Stewart home at 416 Zion Street in Nevada City from approximately 1898 through 1908 while he was foreman at the Champion Mine. Seen here in a photograph taken by James, from left to right, are (first row) Jimmie, Gladys, and Bernice; (second row) Beatrice, Mary Jane (Chegwidden), and Ida. (Courtesy Jan Davis.)

Pictured here around 1899, the children of James and Beatrice Moore, from left to right, are (first row, in white) Gladys and Jimmie; (second row) May, Nellie, and Ida. Ida graduated from Nevada City High School in 1908. Niles P. Searls, son of Fred Searls, was the only boy—out of nine students—to graduate that year. (Courtesy Jan Davis.)

Pictured above around 1885 are gold miner William Thomas, his wife, Lavonia (Hicks), and their children Richard Irving (on his mother's lap) and Elsie Elizabeth (on the table). Thomas was killed in the October 9, 1900, explosion at the Mountaineer Mine on Deer Creek in Nevada City. (Courtesy Jan Davis.)

In the 1925 Fourth of July Parade, the Miner Workers Protective League's entry depicted the evolution of mining through three mining techniques—panning, the rocker, and a mini quartz mill. The league, created for men employed in the mining industry, functioned as a labor organization, and an important function of the group was to assist the families of miners in sickness, accidents, or death. (Courtesy Searls Library.)

Born in 1872, Marye A. Pickle of Columbia Hill changed her name to Gertrude Phkill. A Cinderella story, her fortunes followed after becoming the nursemaid of Mrs. O'Kane in Menlo Park. Falling in love and marrying the son of her employer, Jimmie O'Kane, Gertrude lived happily ever after on the O'Kane estate and drove one of the first electric automobiles on the peninsula. (Courtesy Searls Library.)

Joseph (Joe) Garesio was born in San Bruno, California, in 1912. His father had arrived in 1909 and his mother Francesca, with sons Albert, age 6 (right), and Thomas, age 10, arrived in 1910. The family bought a ranch in Indian Flat where they had an orchard, a vineyard, and grew vegetables. Joe later became a miner, working in several mines in Grass Valley and Nevada City. (Courtesy Joe Garesio.)

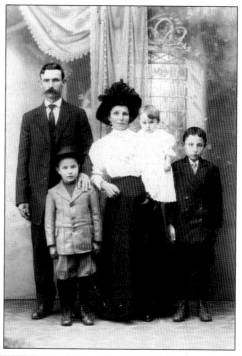

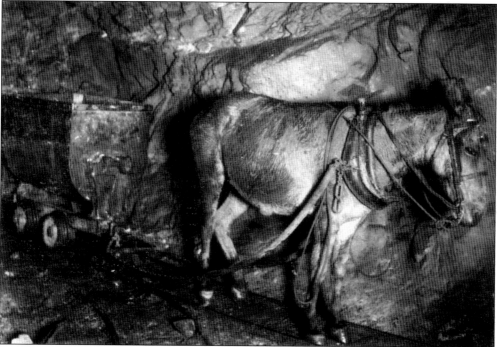

Hinney the mule worked underground at the Empire Mine. The mules working underground at the Champion Mine were reported to be tobacco chewers. While waiting for the ore cars to be loaded, they would take a chunk of tobacco and chew it, a habit acquired from the miners who also chewed tobacco. One mule resorted to tearing the miners' pants to get tobacco from the pocket. (Courtesy Searls Library.)

Little Orlanda Carter is not having a yard sale in front of her house on Main Street, she is probably just showing off her array of dolls and toys for this c. 1890 photograph. Orlanda was born in North Bloomfield in 1883, the daughter of Randolph and Gertrude (Black) Carter. She became Mrs. Morrison and moved to Colusa County. (Courtesy Searls Library.)

While attending Stanford University, Herbert Hoover worked for a summer in Nevada County. After graduation, Hoover needed a job, so he came back to Nevada County. His first place of employment was at the Reward Mine for $2 a day. In this photograph, former President Hoover is giving an address on July 4, 1935, at Memorial Park in Grass Valley. (Courtesy Searls Library.)

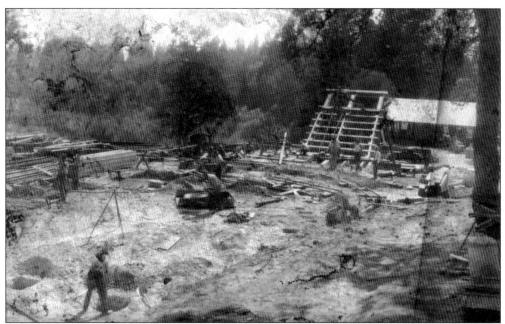

Constructing a shaft involved excavation and lining of a near-vertical tunnel. The excavation equipment had to support the men and their gear as the shaft went deeper into the earth. This undated photograph of an unknown mine shows the sinking from the surface. Shafts could be incidental to other underground construction such as ventilation shafts, vehicular tunnels, and powerhouses. (Courtesy Searls Library.)

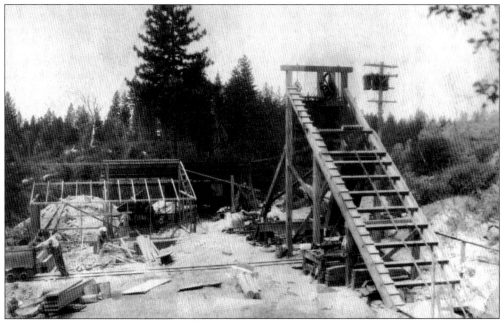

In this photograph, the head frame has been erected. In the early days, head frames were made out of wood. They were less expensive but did not hold up like steel and concrete and were not fireproof. The only clues to identify the era are the old car and truck at the top photograph and the utility line at the bottom. (Courtesy Searls Library.)

In 1856, 20-year-old George Hearst arrived at a quartz mine in Nevada City, mined for three years, and then went to the Washoe to prospect. He returned to Nevada City to acquire money to purchase a one half interest in the Ophir Mine in the Comstock Lode. He had interests in the Nevada County mines of Yuba, Ophir, Lecompton, Jim, the old Pittsburgh, and Sneath and Clay. (Courtesy author.)

In the early 1860s, the Yuba Mine was located on the south fork of the Yuba River. By 1884, George Hearst was one of the owners, and the Yuba was one of the most productive mines in Nevada County. Hearst had told T. W. Sigourney, a mining businessman who acted as Hearst's agent, to purchase every foot of ground lying between the Town Talk tunnel and Hamilton McCormick's property. (Courtesy Searls Library.)

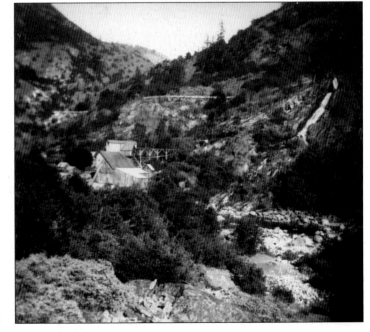

The names Arthur De Wint Foote and
Arthur Burling Foote were important
to Nevada County mining history but
it would be Mary Hallock Foote, wife of
Arthur De Wint and mother of Arthur
Burling, who would gain national literary
fame. Hallock Foote is recognized as the
first female illustrator and writer of the
American West. She lived at the North
Star Mine in Grass Valley, illustrated
books, and wrote short stories published
in *Century* and *Scribner's* magazines.
(Courtesy author.)

William and Sophia Kohler Sr. were
California pioneers who lived in Nevada
City, then Grass Valley. This is the mine
at the Kohler Ranch, *c.* 1908, owned by
sons William and Theodore. Pictured
here, from left to right, are (first row,
sitting on the rocks) Clara Biroth and
Billie Zandow; (second row) Ted Kohler,
Agnes Saddler Smith, Ida Biroth, Louisa
Zandow, Minnie Kohler, William Kohler
Sr., William Zandow, and Will Kohler.
(Courtesy Searls Library.)

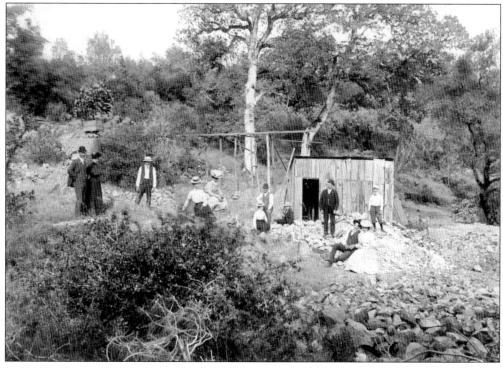

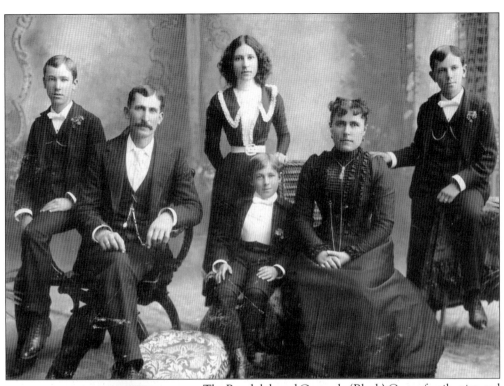

The Randolph and Gertrude (Black) Carter family, pictured here from left to right, are (first row, sitting) William L., Randolph, and Orlanda; (second row) Lawrence, Gertrude, and George. Randolph, born in North Bloomfield in 1858, later moved to Nevada City and went to work in a butcher shop at age 13. He worked at the Keystone Market on Broad Street for many years. His son George became Nevada County sheriff from 1927 to 1933. (Courtesy Doris Foley Library.)

William and Nancy Carter were pioneers of Nevada County and settled in North Bloomfield. He was a miner, and the family operated an early hotel there. His son Randolph had the distinction of subscribing to the *Union* newspaper in Grass Valley longer than any other customer, receiving the newspaper for 54 years before his death in 1936. (Courtesy Doris Foley Library.)

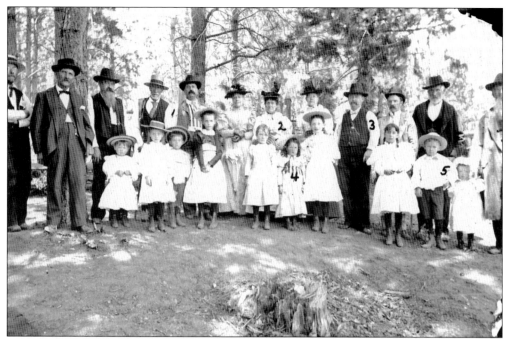

In 1898, a big Fourth of July Parade was held in Nevada City. The town of North Bloomfield had their own celebration, including a picnic and baseball game, in which they defeated the French Corral Mine team. Identified by number are Lester L. Myers (1), Annie Myers (2), Walter Mobley (3), Elyse Myers (4), and Lester Myers (5), the mining superintendent at the Malakoff Mine. (Courtesy Searls Library.)

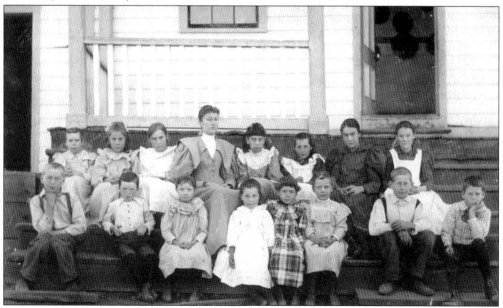

In 1874, the new Boca schoolhouse was erected. This September 2, 1875, photograph of the school shows Mary Hurley, the schoolteacher for only one year. Boca's largest industries were lumber, ice, and beer, which became famous on the California coast after a beer plant was constructed in Boca in August 1875. (Courtesy Searls Library.)

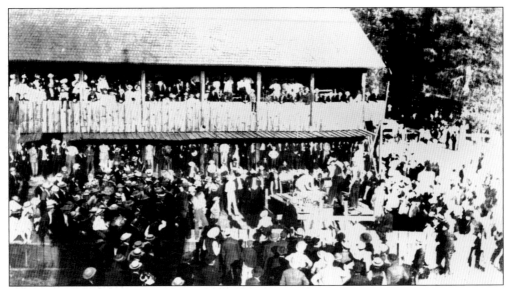

The Knights of the Royal Arch picnic at Glenbrook Park and Racetrack, the world's first outdoor electrically lit sports event, came to light on September 8, 1887, and was the biggest news story of 1887 in Nevada County. Horse racing was the most popular attraction in the northern mines in 1873. One of the more popular contests at the picnic was the drilling contest, pictured at right center. (Courtesy Searls Library.)

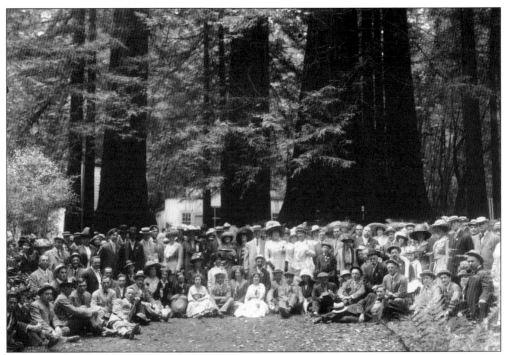

The annual Pioneer Day, created by the Native Daughters and Native Sons of Nevada City, pays tribute to the brave men and women who settled in California and laid the foundations for the "greatest state in the American Union." To be called a "pioneer," one must have arrived in California before January 1, 1862. (Courtesy Searls Library.)

Charles Frederick Bristow, born in Cherokee in 1875, was killed in an accident at the Gaston Ridge Mine when he went behind the battery frame to oil the bearings of the main shaft. The ends of his loose jumper caught on the shaft while it was running, and he was not found until two hours later. (Courtesy Kathi Bristow.)

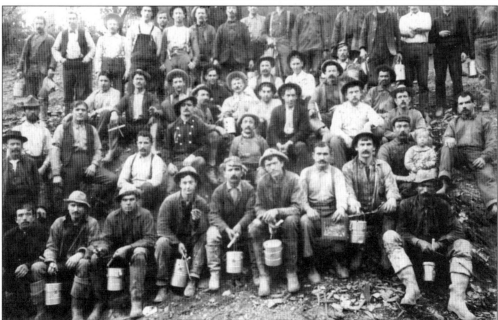

Cornish miners had been sent to America as early as 1778 to inspect the copper deposits of the Lake Superior region. With not many mining opportunities left in Cornwall, men came to the mines of Grass Valley in the 1840s and 1850s and brought their unique lunch pails with them. (Courtesy Searls Library.)

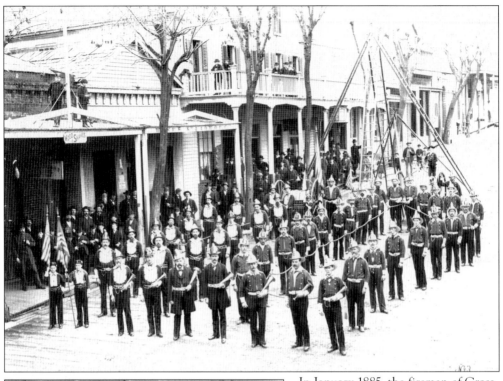

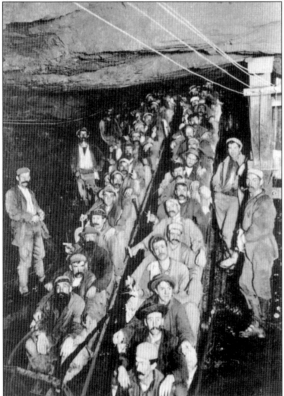

In January 1885, the firemen of Grass Valley presented a photograph of their force to each of the Nevada City fire companies. The Pennsylvania Engine Company of Nevada City reciprocated by having this 1885 photograph taken in the middle of Broad Street in Nevada City. Their leader was chief engineer Lucius Marshall Sukeforth. (Courtesy Searls Library.)

In 1894, a Cornish woman visiting Grass Valley thought she had found the town of Porthtowan, Cornwall, as she proclaimed there were many more Porthtowan folks in California than in England. A majority of the miners working and living in the Grass Valley district were descendants of Cornish men and women. (Courtesy Brita Rozynski.)

Charlie Lutz was the son of pioneer parents who arrived in Nevada City in 1850. His father opened a shoe store in Nevada City, which was later destroyed in the 1863 fire. Lutz became a plumber and constructed this water tank up in the Washington area. He lived to be almost 90 years of age and died in French Corral in 1966. (Courtesy Searls Library.)

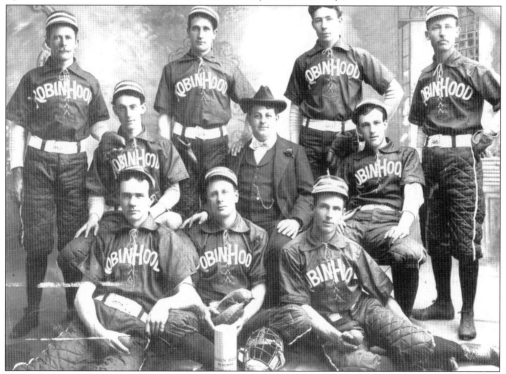

In 1910, baseball was deemed the "greatest game in the world," and towns all over the country were starting teams. In April, Grass Valley players and fans held a meeting at city hall to organize a club. On May 15, Mayor James C. Conway threw the first ball for the baseball club The Colts, against a San Francisco team. This undated photograph is of a local baseball team. (Courtesy Searls Library.)

ACROSS AMERICA, PEOPLE ARE DISCOVERING SOMETHING WONDERFUL. *THEIR HERITAGE.*

Arcadia Publishing is the leading local history publisher in the United States. With more than 3,000 titles in print and hundreds of new titles released every year, Arcadia has extensive specialized experience chronicling the history of communities and celebrating America's hidden stories, bringing to life the people, places, and events from the past. To discover the history of other communities across the nation, please visit:

www.arcadiapublishing.com

Customized search tools allow you to find regional history books about the town where you grew up, the cities where your friends and family live, the town where your parents met, or even that retirement spot you've been dreaming about.